Historic Homes and Inns of Carmel-by-the-Sea

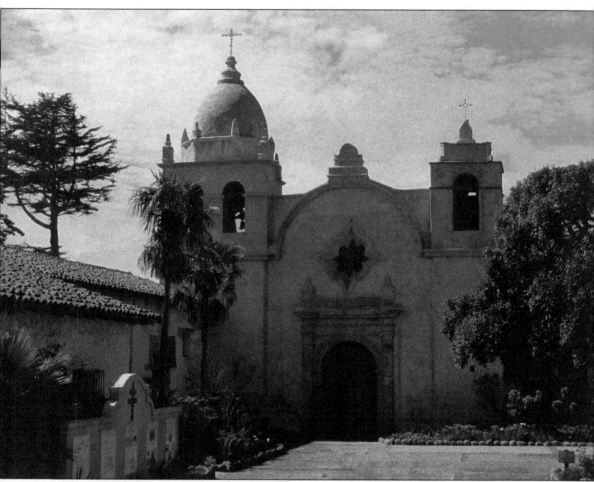

CARMEL MISSION. Franciscan father Junípero Serra founded Mission San Carlos Borroméo in 1771 near the Carmel River. He used it as his headquarters and was buried there in 1784. Two real estate agents, brothers Santiago and Belisario Duckworth, established Carmel City as a Catholic summer resort, which existed from 1888 to 1902. It became Carmel-by-the-Sea in 1903 under developers Frank Devendorf and Frank Powers. (Authors' collection.)

FRONT COVER: Henry Johnson House, located on Carmel Point, is one of only five houses built directly on Carmel's seacoast. It has sweeping views of Carmel Bay and Pebble Beach to the north, with Pescadero Point in the distance. (Authors' collection, see page 38)

BACK COVER (from left to right): La Playa, the hotel known as the "Grande Dame of Carmel" (Authors' collection, see pages 50–51); Märchen Haus, created by Carmel's "builder of dreams," Hugh Comstock (Authors' collection, see page 58); Edward Kuster House, a stone castle constructed on Carmel Point (Authors' collection, see page 32)

CONTENTS

ACKNOWLEDGMENTS

Special thanks go to R.M.M. and B.D. for their continued advice and support.

Research material was obtained through public records. We would like to thank the Community Planning and Building Department staff at Carmel City Hall for their assistance. Librarians Ashlee Wright at the Henry Meade Williams Local History Department of the Harrison Memorial Library in Carmel-by-the-Sea and Dennis Copeland at the Monterey Public Library California History Room were helpful. We also thank local architectural historians Kent Seavey and Richard Janick for their many years of research, which laid the foundation for this book. All photographs were taken on public property and are courtesy of the authors.

To be designated as historic, a property must be at least 50 years old, with a significant builder and/or notable resident. Whenever possible, original names of owners who commissioned the building design were used. There are no street numbers in Carmel-by-the-Sea; therefore, addresses are given by compass coordinates. The number in front of the direction indicates how many lots away the property is from the intersection. An interactive map of the homes and inns in this book can be found online at www.goo.gl/4FVmOz.

INTRODUCTION

Carmel-by-the-Sea's historic homes and inns have mirrored architectural trends in the country but with unique qualities based on the individuality of the town's residents and builders. When Carmel City was founded in the late 19th century, the houses were typically vernacular cottages, mostly constructed by carpenters such as Delos Goldsmith, the town's first builder. Some had Victorian era style influences. In Carmel-by-the-Sea's first two decades, from early 1900 to 1920, it was a haven for Bohemian artists and writers, along with professors, mostly from the San Francisco Bay Area. They were content with simple Craftsman-style bungalows or beach cottages, often board-and-batten structures, some of which they constructed themselves.

Shortly after it was founded, a young man from Mendon, Utah, whose experience was as a house painter, moved to Carmel-by-the-Sea in 1904 and soon became the town's official builder. Thus, Michael ("M.J.") Murphy Jr. (1885–1959) began four decades as Carmel's most prolific contractor, until his retirement in 1941. By the 1930s, it was estimated that he built four out of five houses in town. No one else constructed more homes and buildings in Carmel's history, a total of 350. When he started his career, Murphy frequently constructed Craftsman-style cottages using local, natural building materials. As the country entered the Roaring Twenties and its economic boom, Murphy's designs evolved with the times and with his clients' wants. He built larger and more sophisticated residences, often in the European Revival styles (English, French, and Spanish) popular in that period. No matter the style, M.J. Murphy was always known for his quality craftsmanship.

Carmel attracted new residents along with wealthy summer visitors who constructed second or vacation houses during this era. These homes were often done on a grander scale not seen before in the town. In fact, some of Carmel-by-the-Sea's inns had once been large residences, while others were groups of guest cottages. Many homeowners, as well as designers and builders, had been to Europe—whether by heritage or through travel, education, or service in World War I—and were familiar with European architecture. Notable architects were commissioned primarily from the San Francisco Bay Area to build these individual custom homes and inns. They included Albert Farr, Henry Gutterson, and George McCrea, along with the firms Blaine and Olson and Swartz & Ryland. After he was hired to design a massive stone residence on the Carmel Highlands coastline, Southern California architect Charles Greene relocated to Carmel-by-the-Sea.

In the mid-1920s, a rancher from Santa Rosa who first came to Carmel to visit his artist sister and her husband forever left an imprint that defined the quaint architectural character of the village. Hugh W. Comstock (1893–1950) was born in Evanston, Illinois, and moved to California with his family in 1907. During that trip to Carmel in 1924, he met and shortly thereafter married local doll designer Mayotta Browne. At a cost of $100, combined with admiration for British children's book illustrator Arthur Rackham, but no construction training—just his imagination—Comstock built a 244-square-foot studio (Hansel) as a showcase for his wife's doll

7

collection. The whimsical little cottage in the woods triggered the fairy tale building trend that established the familiar, charming appearance of the village. Carmel-by-the-Sea's architecture thereafter became identified with the Tudor Storybook style.

Other main local builders of the 1920s and 1930s in Carmel were Lee Gottfried, Ernest Bixler, Percy Parkes, Frederick Bigland, Guy Koepp, George Whitcomb, and Miles Bain. From that time onwards, creative and independent women such as Ann Nash and Dorothy Bassett, Dene Denny and Hazel Watrous, and Laura Maxwell—often without any building experience—also crafted houses. The Great Depression years of the 1930s led to the construction of more modest and simpler houses, with less adorned architecture. Noted Bay Area architect Julia Morgan designed a house in the Minimal Traditional style, which overlooked the Carmel Mission. Local architect Robert Stanton was one among several who devised a house with prefabricated building materials to cut costs.

In 1941, an artist-by-training designed Carmel's first Modernist subdivision, Sand and Sea. Jon Konigshofer (1906–1990) was born in Alameda, California, and studied art and design at the Art Students League in New York City and the California College of Arts and Crafts in the East Bay. He arrived in Carmel-by-the-Sea in 1937 and spent a year as a draftsman for M.J. Murphy before he opened his own practice in 1938. His first few years were centered on traditional designs; for example, his remodels of the town's oldest and main hotels: the Pine Inn and La Playa. However, with awareness of innovative architect Frank Lloyd Wright's concept of the Usonian House, Jon Konigshofer soon developed a modern style of his own and became a leader in the Second Bay Region style of architecture, which emerged in the 1940s. The outbreak of World War II brought shortages in building supplies and uncertainty over construction, yet when the war ended, the great postwar building boom began. Using prefabricated materials and utilizing Carmel's heretofore unused steep lots, at a cost under $10,000 including furnishings, Jon Konigshofer's pioneering and trendsetting Hillside House modernized Carmel and filled the demand for affordable housing. Others who built houses in the Second Bay Region style in Carmel during those years were prominent Bay Area architects Gardner Dailey, Henry Hill, William Wurster, and Clarence Mayhew.

The San Francisco Museum of Art showcased 52 regional, modern architectural works in the 1949 exhibit Domestic Architecture of the San Francisco Bay Region. Two houses by Henry Hill in Carmel, one by the firm Wurster, Bernardi & Emmons in Carmel, and one by Jon Konigshofer in Pebble Beach were selected from the Monterey Peninsula as outstanding representations of the Second Bay Region style. In 1950, the Monterey Peninsula Herald named M.J. Murphy, Hugh Comstock, and Jon Konigshofer as the three most influential architects in Carmel-by-the-Sea's history. Though none of them had an architectural degree, they made the most impact in shaping the town's architectural look in its first five decades.

Frank Lloyd Wright's modern, Organic design style was seen in the early 1950s in Carmel in three out-of-the-ordinary coastal houses built as if they had grown out of the rugged shoreline. One was by Wright and two were by local architect Frank Wynkoop. A student of Wright's, architect Mark Mills designed distinctive homes in Carmel that carried the Organic-Wrightian philosophy into the late 1950s and 1960s. The Third Bay Region style of architecture came about during the 1960s and continued to unite Craftsman traditions with the natural surroundings. It was exemplified in Carmel by the work of Bay Area architect Charles Moore, along with Henry Hill and Southern California architect Marcel Sedletzky. Mills, Hill, and Sedletzky all became residents of the town.

Carmel-by-the-Sea covers one square mile of land along Northern-Central California's Pacific Coast, and since the earliest days, it has been described as a village in the forest. Through the years a wide range of individuals, including civic, business, academic, cultural, and entertainment figures, have been drawn to the town's charm. These people, along with architects and builders, created significant and memorable historic homes and inns, which shaped Carmel-by-the-Sea into a one-of-a-kind magical place with distinctive architecture that reflects the individuality, creativity, and unique character of its residents and its beautiful and ideal picturesque setting.

One

NORTHWEST
SAND AND SEA

ALFRED P. FRASER HOUSE. This large Craftsman-style house was built in 1913 on the northwest corner of Camino Real Street and Ocean Avenue. The builder's name is not known. It was the home of Carmel's first mayor, Alfred Fraser, a Harvard-educated lawyer and judge who served from 1916 to 1920. Carmel-by-the-Sea became incorporated as a city on October 31, 1916.

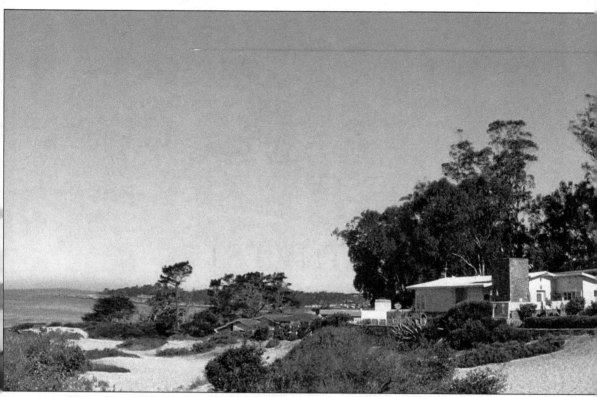

KONIGSHOFER-WHITE SAND AND SEA HISTORIC DISTRICT. In 1941, designer Jon Konigshofer created a five-house residential development for real estate agent Elizabeth McClung White along the Carmel Beach sand dunes on San Antonio and Fourth Avenues. The early Modernist houses combined traditional Craftsman features, respect for the natural environment, and joined indoor and outdoor living space, as part of the Second Bay Region style of architecture. *Sunset* magazine featured one in 1947. The builder was Roger Gottfried. Konigshofer was best recognized

Published by Arcadia Publishing
Charleston, South Carolina

Library of Congress Control Number: 2015915212

For all general information, please contact Arcadia Publishing:
Telephone 843-853-2070
Fax 843-853-0044
E-mail sales@arcadiapublishing.com
For customer service and orders:
Toll-Free 1-888-313-2665

Visit us on the Internet at www.arcadiapublishing.com

HISTORIC HOMES AND INNS OF CARMEL-BY-THE-SEA

Alissandra Dramov and Lynn A. Momboisse

ARCADIA
PUBLISHING

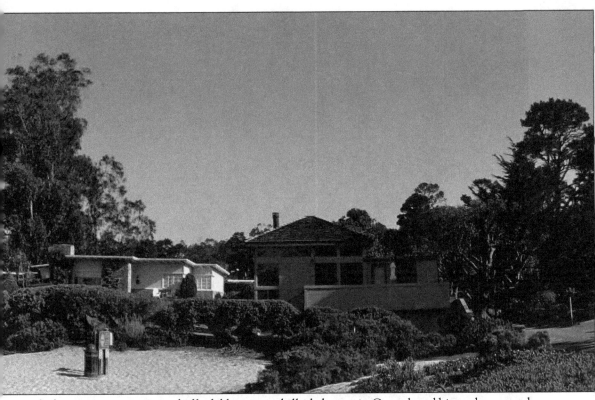

for his many innovative and affordable postwar hillside homes in Carmel, and his work appeared in architectural trade and popular magazines such as *Life* and *House Beautiful*. He also designed the Pebble Beach and Tennis Club, John Gardiner's Tennis Ranch in Carmel Valley, and 50 fine homes in Pebble Beach, including ones for entertainer Bing Crosby and movie producer Robert Buckner.

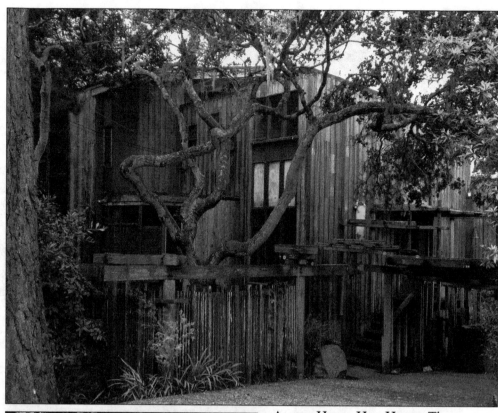

ALBERT HENRY HILL HOUSE. The prominent English-born Bay Area architect designed his vacation house in 1961 and permanently moved to Carmel in 1971. The three-story Third Bay Region–style house was constructed on a steep lot on Lopez Avenue 3NW of Fourth Avenue. As first pioneered by Jon Konigshofer in the 1940s, modern hillside house design on Carmel's steep lots gave homes privacy and views.

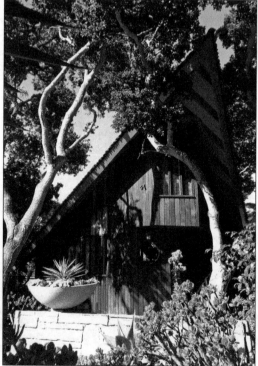

JOHN COSMAS WEEKEND HOUSE. In 1961, Henry Hill created this residence on Lopez Avenue 5NW of Fourth Avenue. The massive roof, which appeared as if it is folded, was inspired by the Organic design style of architect Frank Lloyd Wright.

MR. AND MRS. M.D. PERKINS HOUSE. Architect Joe Wythe designed this house in the Organic architectural style defined by Frank Lloyd Wright on a steep grade lot on the southwest corner of Lincoln Street and Fourth Avenue. Structural engineer M.D. Perkins contributed to the building of his modern house in 1963.

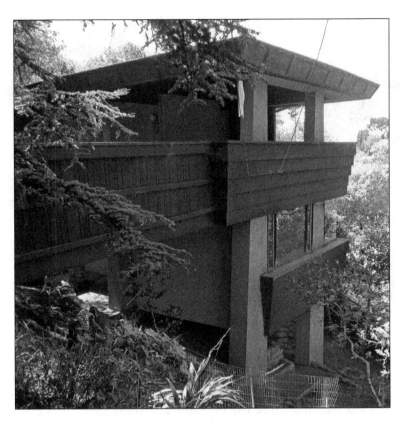

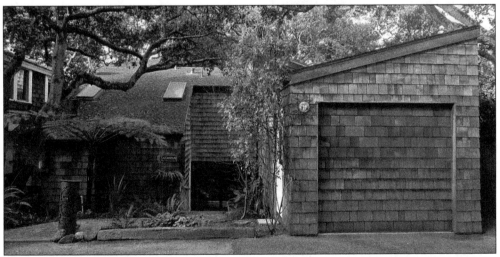

WARREN SALTZMAN HOUSE. The two-story, wood-shingled house on a steep lot represents the Third Bay Region style of architecture. Built in 1966 on Palou Avenue 6NW of North Casanova Street, it is the only one in Carmel designed by noted Bay Area architect Charles Moore. This style of architecture was best exemplified in Northern California's Sea Ranch coastal residential development of the mid-1960s, which Moore helped design.

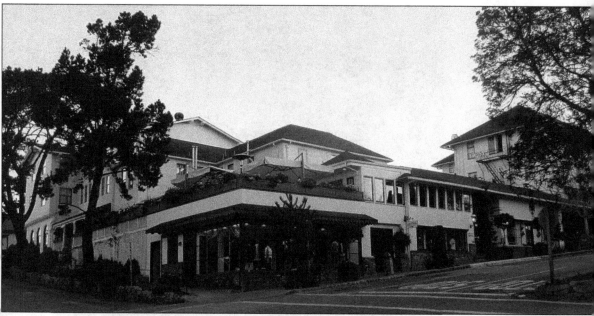

PINE INN. Carmel's oldest hotel began as the two-story Craftsman-style Hotel Carmelo, built by Delos Goldsmith in 1889 on the northeast corner of Ocean Avenue and Junipero Street. In 1903, the hotel was moved five blocks by mules and wooden rollers to its current location on the northeast corner of Ocean Avenue and Monte Verde Street. It became the Pine Inn, the social gathering place for generations of Carmelites. Architect Thomas Morgan enlarged it with a sunroom, restaurant, and stable. M.J. Murphy, in one of his first paid jobs, did the construction. In the late 1920s, Oakland architects Blaine and Olson remodeled the hotel in the popular Spanish Revival architectural style, with a stucco exterior. The Pine Inn was expanded to cover nearly the entire city block, and parts of the hotel became three stories high. Once again, M.J. Murphy was the builder. John B. Jordan, a theater actor and businessman, was the owner at the time. He was mayor of Carmel from 1926 to 1928.

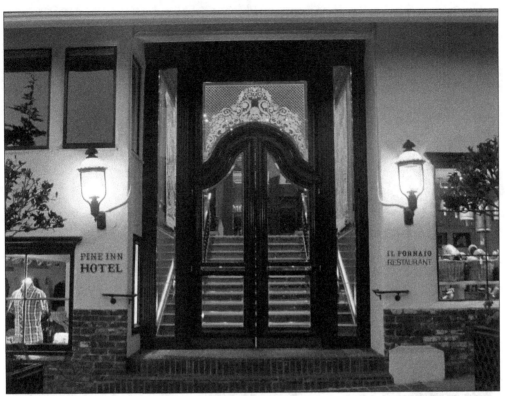

PINE INN OCEAN AVENUE ENTRANCE. Designer Jon Konigshofer remodeled the hotel in the 1940s, under the ownership of Harrison Godwin who had previously run the La Playa Hotel with his brother Fred. A rooftop garden dining area, 12 retail shops, and a pub were built, along with a Victorian-themed interior. In 1972, a glass gazebo dome was added to the dining area, where the Il Fornaio Italian restaurant bakery is located.

TALLY HO INN. When the Pine Inn first opened, extra guests stayed in cottages located across the street on Monte Verde 2NW of Ocean Avenue. Popular nationally syndicated cartoonist Jimmy Hatlo hired Hugh Comstock to construct a large adobe brick house on the property in the 1940s. A decade later, his residence became the Tally Ho Inn, a sister hotel to the Pine Inn.

FIRST MURPHY HOUSE. Soon after he first arrived in Carmel, while still in his teens, M.J. Murphy built a vernacular cottage for his widowed mother, Emma, in 1902. To save it from demolition in 1990, the house was moved by crane to its current location on Lincoln Street 2NW of Sixth Avenue, now the site of the Carmel Heritage Society.

JAMES FRANKLIN MURPHY HOUSE. In 1931, M.J. Murphy constructed the Tudor Revival–style house on Mission Street 2NW of First Avenue for his first-born son, who was delivered in 1904 by Carmel-by-the-Sea's cofounder James Franklin Devendorf and hence named after him. As an adult, Murphy's son managed his father's companies, and today, Murphy's relatives still run M.J. Murphy Lumber and Hardware in Carmel Valley.

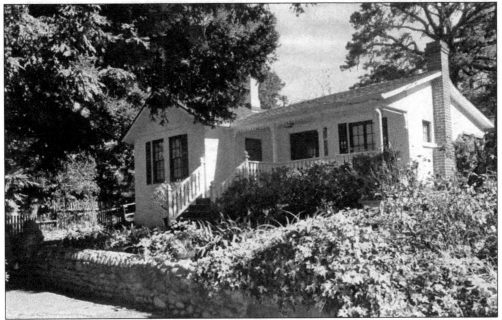

BENJAMIN TURNER HOUSE. In 1898, the year he came to Carmel City, Benjamin "Ben" Turner, the master stonemason, constructed the first brick house (now painted white) at Monte Verde Street 2SE of Fifth Avenue. He did the masonry for many of Carmel-by-the-Sea's earliest homes. In 1915, his son Harry joined the business, and Harry's son George later became a third-generation stonemason.

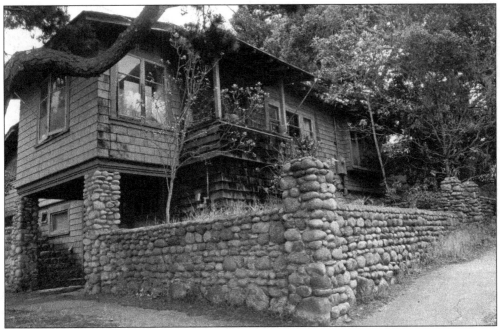

RUDOLPH OHM HOUSE. This Craftsman-style house on the southeast corner of Monte Verde Street and Fifth Avenue was built next door to Ben Turner's house in 1907 for his daughter Emma and his son-in-law Rudy Ohm. Turner built the stone retaining walls and brick chimney.

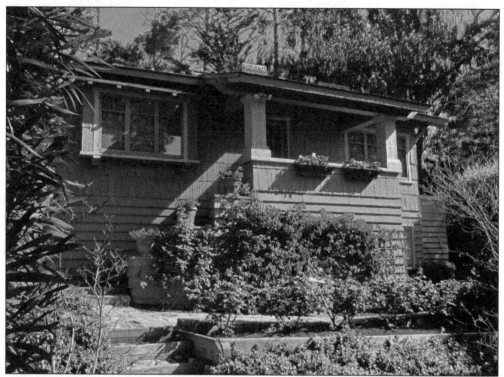

ADELAIDE J. TRETHAWAY HOUSE. In 1914, this Craftsman-style cottage was built on Lopez Avenue 2NE of Fourth Avenue. Poet Robinson Jeffers (1887–1962) and his family lived there from 1917 to 1919 while their stone house on Carmel Point, Tor House, was under construction.

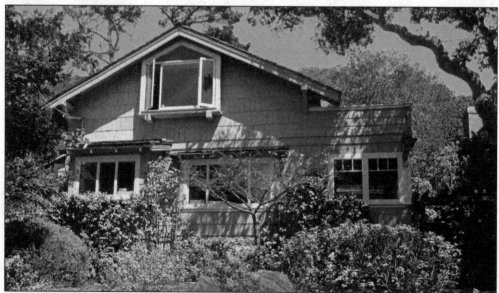

PROF. KARL RENDTORFF HOUSE. M.J. Murphy constructed the Craftsman-style house on Camino Real Street 7NE of Ocean Avenue in 1913 for the Stanford University professor of Germanic languages. Between 1904 and 1920, there were so many summer houses owned by university professors along Camino Real Street that several blocks in the area were nicknamed "Professors' Row."

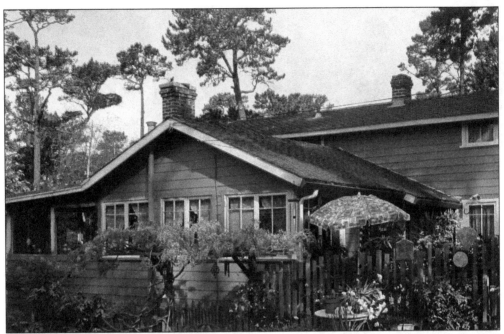

JO MORA HOUSE. Artist and sculptor Joseph Jacinto Mora, who was born in Uruguay, designed and built his Craftsman-style cottage on San Carlos Street 3SW of First Avenue in 1921. Mora's most notable work on the Monterey Peninsula was the Father Junípero Serra Memorial Cenotaph at the Carmel Mission.

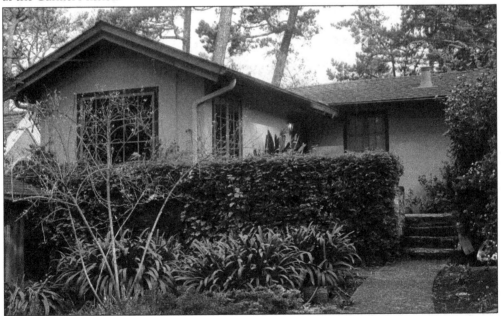

FRANCIS WHITAKER COTTAGE. The town's foremost blacksmith lived in the Craftsman-style cottage designed and built for him in 1928 by M.J. Murphy 2W of Mission Street on the north side of Vista Avenue. Whitaker did much of the decorative ironwork and metalwork on homes and buildings in Carmel and Pebble Beach for three decades, from the late 1920s. With his friend John Steinbeck, he was active in the town's political and intellectual circle during the 1930s.

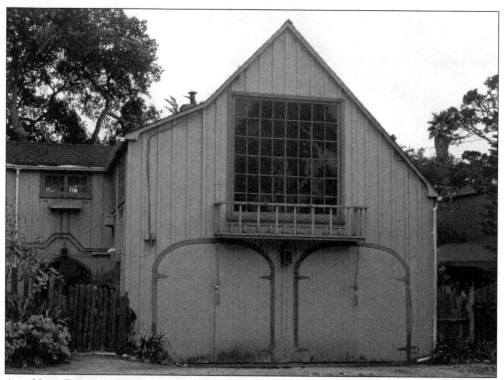

ANN NASH-DOROTHY BASSETT HOUSE. In Carmel's history, many independent and creative women crafted their own houses. In 1921, two Bay Area women without any construction experience built a Craftsman-style cottage on the southwest corner of Junipero Street and Alta Avenue. In 1926, two other notable female builders in Carmel, Dene Denny and Hazel Watrous, added a two-story carriage house.

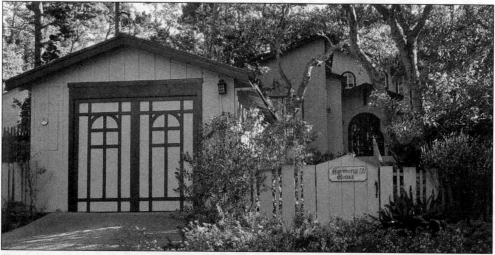

DENNY-WATROUS STUDIO. Carmel's musical and cultural impresario duo, Dene Denny and Hazel Watrous, put their many skills to use for nearly three decades. They designed 30 houses, most in the northern part of town. The two held piano concerts and other events in their eclectic Craftsman-style house, which they built on Dolores Street 4NE of Second Avenue in 1922 and expanded into a studio in 1926.

THOMAS V. CATOR HOUSE.
The Tudor Revival–style
house with Storybook features
was constructed in 1923 on
the northeast corner of Lopez
and Fourth Avenues. The
builder is not known. It was
the residence of composer and
musician Thomas Vincent
Cator until his death in 1931.
His second wife, Hilda, was
the daughter of Carmel writer
John Northern Hilliard.

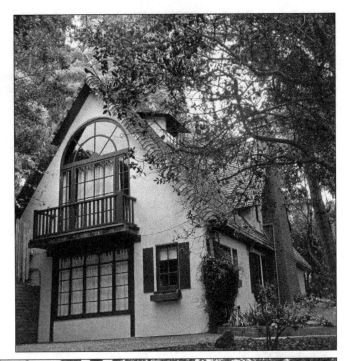

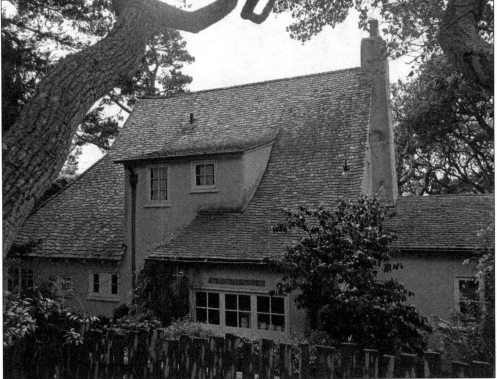

DR. G.E. WOOD HOUSE. Southern California–based architect Edward Huntsman-Trout designed this Tudor Revival–style house built in 1923 on Lopez Avenue 10NW of Fourth Avenue. It resembled farmhouses in rural England from Medieval times.

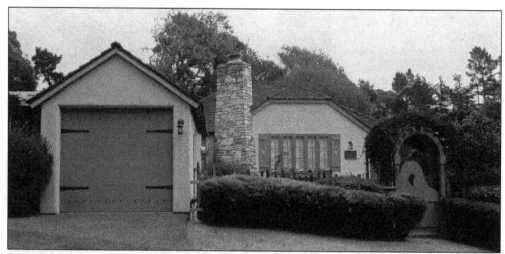

EDWARD FRISTROM COTTAGE. Frederick Bigland designed and constructed the Tudor Revival–style English cottage on Monte Verde Street 4NE of Fourth Avenue in 1927 for Swedish-born artist Edward Fristrom. Bigland, a native of Chester, England, was familiar with small English countryside cottages.

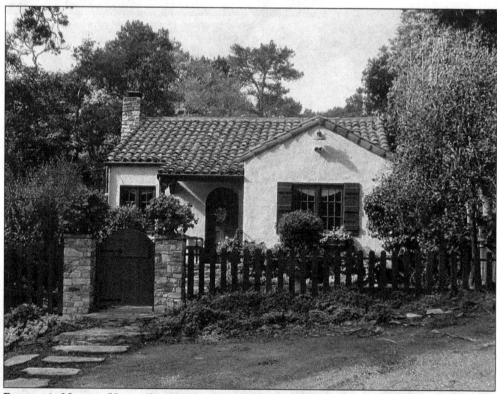

ROBERT A. NORTON HOUSE. In 1928, contractor Earl Percy Parkes designed and built this Spanish Eclectic–style house on Monte Verde Street 5NW of Fourth Avenue. Bob Norton served as a city councilman and police chief during the 1930s. His parents had opened Carmel's first restaurant in 1903.

F. Ten Winkel House.
M.J. Murphy constructed the Tudor Revival–style house in 1925 on the southeast corner of San Antonio and Fourth Avenues. It was designed for Frederick Winkel, the owner of a hardware and furniture store on Ocean Avenue.

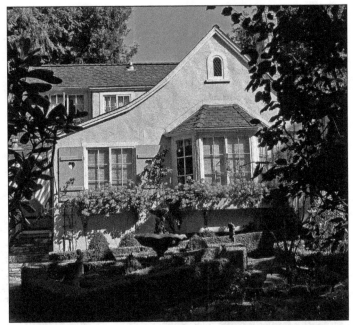

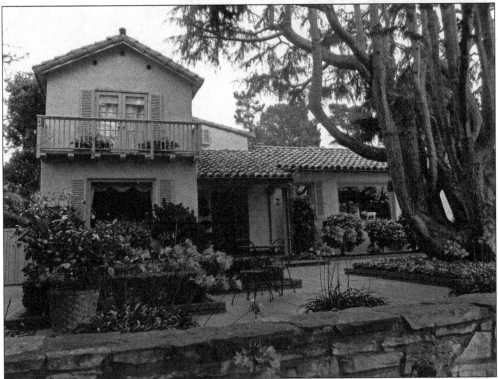

Ten Winkel Spanish House. Located next door on San Antonio Avenue 2SE of Fourth Avenue, this Spanish Eclectic–style house was built in 1930 for the same businessman. Ernest Bixler, who designed and constructed it, became known for this style of architecture in the 1930s. Throughout his 35-year career, which began as a carpenter during the Great Depression, Bixler built 80 houses in Carmel.

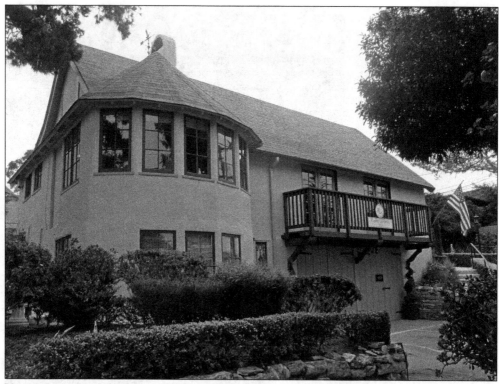

HAPPY LANDING INN. In 1926, M.J. Murphy built a large Tudor Revival–style house for two families from San Jose. Located on Monte Verde Street 3NE of Sixth Avenue, the private home became a boardinghouse in the 1930s. It is now a bed-and-breakfast inn.

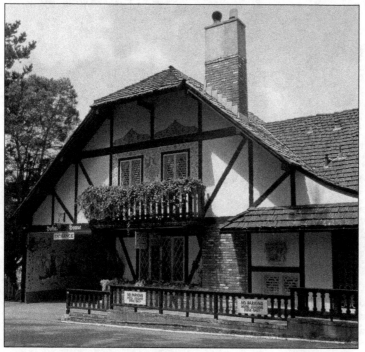

HOFSAS HOUSE. The family-run inn on San Carlos Street 2NW of Fourth Avenue began in 1947 as several cottages. It expanded into a four-story hotel with 38-rooms and the European-inspired architectural look of a Bavarian village. Carmel artist Maxine Albro painted the welcome mural at the front entrance.

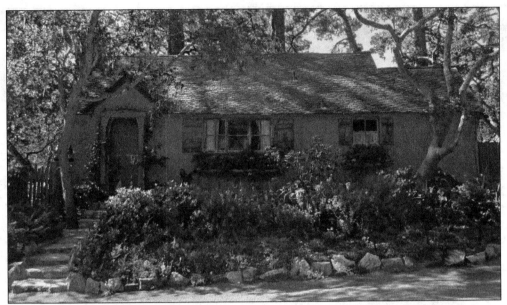

ELSPETH ROSE HOUSE. Hugh Comstock reused design plans for this Tudor Storybook–style house on the northwest corner of North Casanova Street and Palou Avenue, thus nicknamed the "Twin on Palou." It was built in 1929 for local English shopkeeper Elspeth Rose, who ran the antique shop Rose & Rose with her mother in downtown Carmel.

SYLVIA JORDAN HOUSE. In 1929, Hugh Comstock tried his hand at the Spanish Eclectic style design trend of the time. He built this California Adobe–style vernacular house on the southwest corner of Mission Street and Vista Avenue for a schoolteacher.

PERRY NEWBERRY COTTAGE. The vernacular cottage with Craftsman styling and brick and stone veneer, at 2E of Mission Street on the north side of Vista Avenue, was the last house Newberry designed, in 1937, a year before his death. Builder Maynard McEntire did the construction, as Newberry was in poor health. Perry Newberry was a newspaper editor, thespian, and mayor of Carmel in the 1920s.

Two

COAST
SCENIC ROAD AND CARMEL POINT

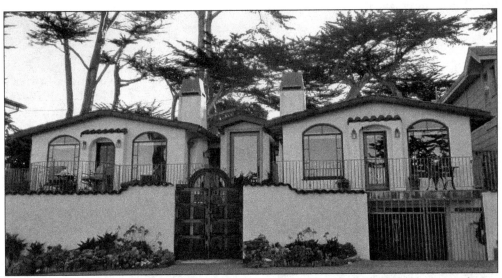

PERIWINKLE AND SEA URCHIN. These twin houses on Scenic Road 3NE of Twelfth Avenue began in 1915 as simple wooden fishermen's shacks visible from the coast. Through the years, they acquired a Mediterranean Revival style with tile roofs and stucco exteriors. Spared demolition in 2000, the two houses were joined into a single residence.

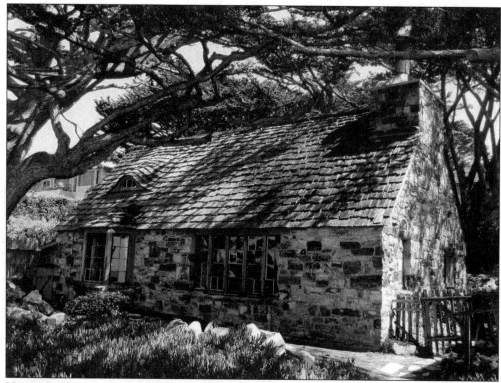

HENRY L. TUSLER COTTAGE. This stone beach cottage sits on the sand dunes of Carmel Beach at Del Mar Avenue 3NW of Eighth Avenue. Designed by architects C.J. Ryland and William Otis Raiguel in 1934, the English-style Cotswold cottage was made of all local materials: Carmel stone from the Santa Lucia Mountain range for the walls and Carmel Valley redwood for the hand-hewn timbers and roof shakes.

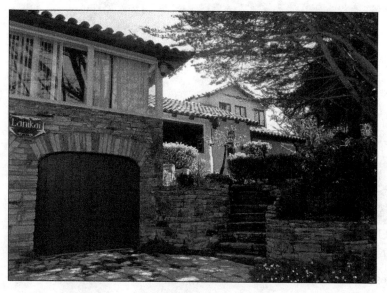

GEORGE E. BUTLER HOUSE. In 1933, Ernest Bixler designed and built the Spanish Eclectic–style house on the northeast corner of Scenic Road and Eighth Avenue. Its design features were similar to houses seen in the hill towns of Spain. Carmel mayor Horace Lyon resided there during his term in the 1950s.

E.H. Cox House. The actor Dick Sargent (born Richard Cox) grew up in this three-story Spanish Eclectic–style Monterey Colonial house on Scenic Road 2NE of Ninth Avenue. It was designed by Guy O. Koepp in 1930. Sargent was best known for his role as the second Darrin Stephens on the long-running television comedy *Bewitched*.

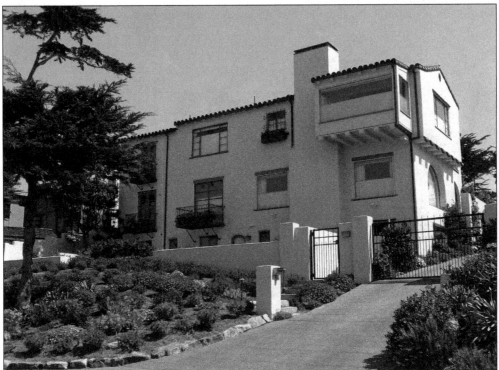

George Graft House. M.J. Murphy built the three-story house in 1929 on Scenic Road 4SE of Eighth Avenue for a retired San Jose businessman, who was the uncle of the Carmel Dairy's Earl Graft. The Spanish Eclectic Mediterranean–style residence resembled ones constructed in Pebble Beach at that time.

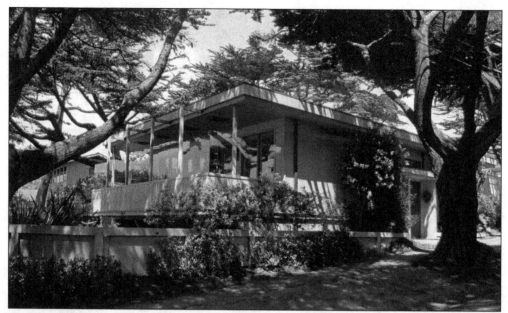

CARL SILVEY HOUSE. Jon Konigshofer designed this Second Bay Region–style house on the northeast corner of Thirteenth Avenue and Scenic Road in 1948 for the owner of Kip's Grocery in downtown Carmel. Silvey's wife was the granddaughter of Honoré Escolle, whose vast land, Rancho Las Manzanitas, became the basis of Carmel City in the 1880s.

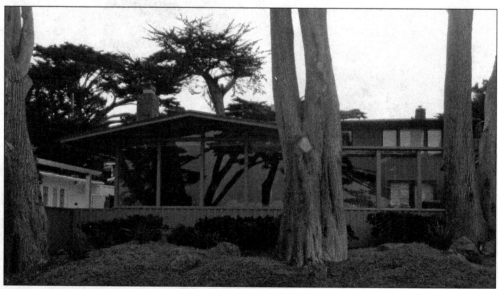

NELSON NOWELL HOUSE. The post–World War II house was built on Scenic Road 4NE of Eleventh Avenue in 1947. Its Second Bay Area Region–style architecture united modern technique with the Craftsman tradition, the work of the prominent Bay Area firm Wurster, Bernardi & Emmons, leaders in the forefront of that style.

HELEN I. PROCTOR HOUSE. Noted Bay Area architect Clarence W.W. Mayhew designed this house on San Antonio Avenue 2NW of Thirteenth Avenue in 1953. It was his only one in Carmel. The wall of windows with a sliding glass door at the back of house combined indoor and outdoor living space, part of the Second Bay Region style.

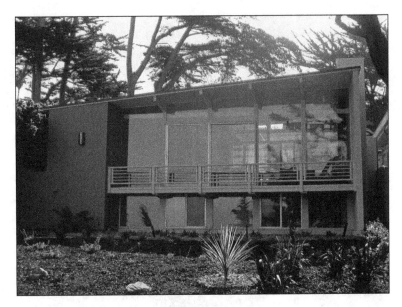

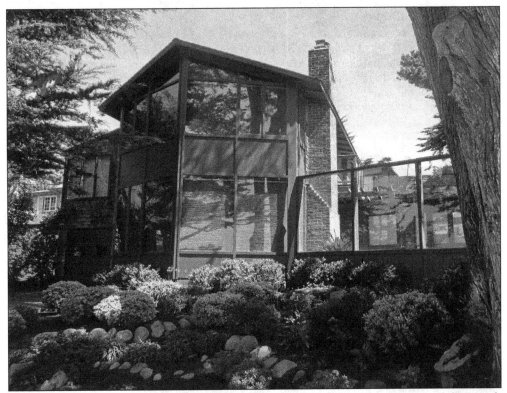

DR. ALBERT K. MERCHANT HOUSE. In 1962, Wurster, Bernardi & Emmons designed this wood-shingled house with large plate glass window walls on Scenic Road at the northeast corner of Eleventh Avenue. It was constructed in the Second Bay Region style of architecture, which used new technology with natural materials.

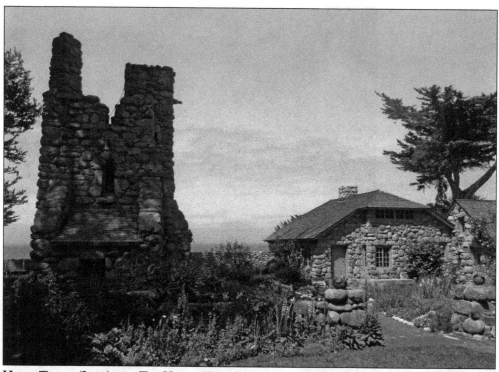

Hawk Tower (Left) and Tor House (Right). Robinson Jeffers, Carmel's most celebrated poet lived here for over 40 years. He trained as a stonemason to help construct the main house at 26304 Ocean View Avenue, designed by M.J. Murphy in 1919. Over the next five years, Jeffers built the adjacent 40-foot-tall granite rock Hawk Tower. Both structures are in the National Register of Historic Places and open for public tours.

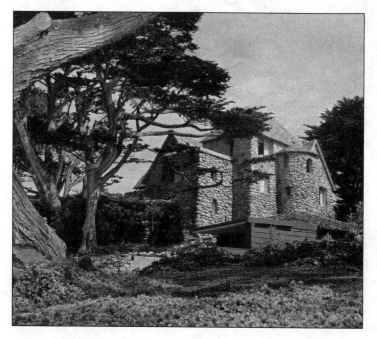

Edward Kuster House. The Medieval European–style stone castle at 26025 Ocean View Avenue was constructed by Lee Gottfried in 1920. Los Angeles lawyer Edward Kuster designed the house. His first wife, Una, married Robinson Jeffers shortly after their divorce in 1913. Kuster had traveled in Europe and established the Golden Bough Theatre and its courtyard shops in downtown Carmel in the mid-1920s, which gave the town its European village look.

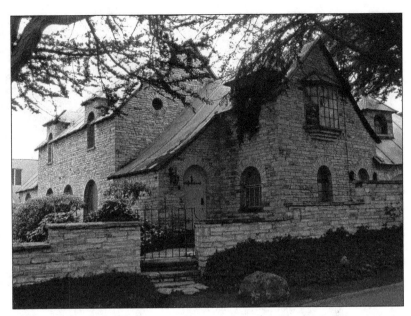

T.J. BRENNAN HOUSE. Ernest Bixler built the large Tudor-style manor house with a Carmel stone exterior at 26097 Scenic Road in the 1930s. Carmel Point remains an unincorporated part of Monterey County, just outside the southern city limits of Carmel-by-the-Sea.

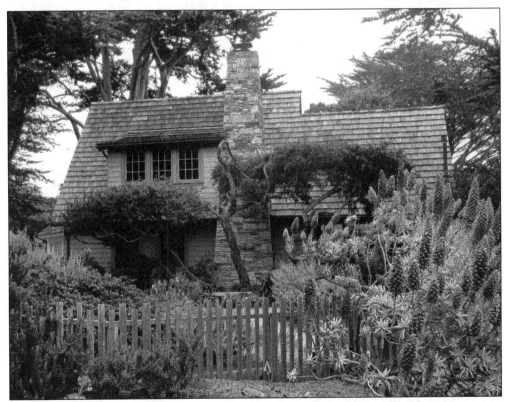

CYPRESS HOUSE. This wood-shingled Craftsman-style house at 26405 Valley View Avenue was one of the first built on Carmel Point during the mid-to-late 1920s. Carmel Point offers views of Carmel Bay, the mouth of the Carmel River, and Point Lobos in the distance.

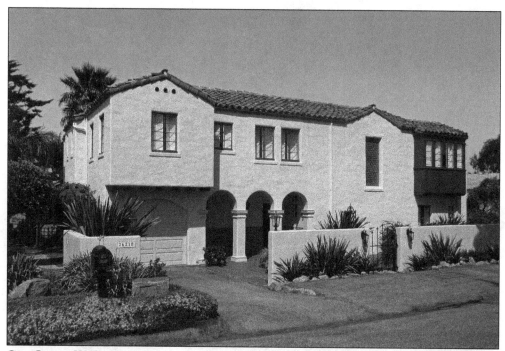

GEN. JOSEPH W. STILWELL HOUSE. In 1934, this two-story Spanish Eclectic–style house at 26218 Inspiration Avenue was built for US Army general Joseph W. Stilwell (1883–1946). He was commander of the Seventh Infantry Division at nearby Fort Ord. Stilwell served in the US Army from 1904 until his death in 1946. His ashes were scattered in Carmel Bay.

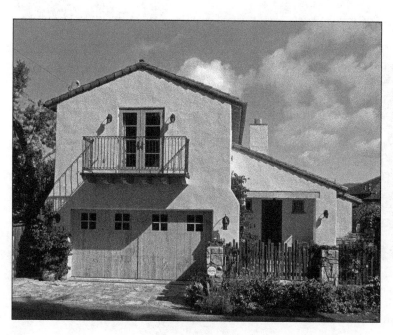

VILHELM MOBERG HOUSE. The Spanish Eclectic–style house at 2423 San Antonio Avenue was built around 1925. While Swedish author Vilhelm Moberg lived there he wrote his four-part series *The Emigrants*, published from 1949 to 1959. The works were translated from Swedish to English by Gustav Lannestock, who lived nearby on Scenic Road.

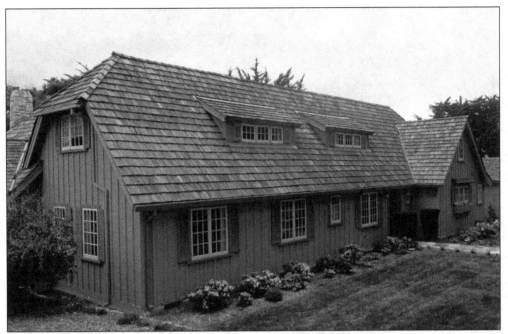

HENRY DICKINSON HOUSE. The retired Chicago attorney designed this large family house at 26363 Isabella Avenue. It was built by M.J. Murphy in 1923, as one of the earliest residences constructed on Carmel Point. Dickinson and his wife, Edith, were founding members of the Carmel Music Society and Carmel Art Association.

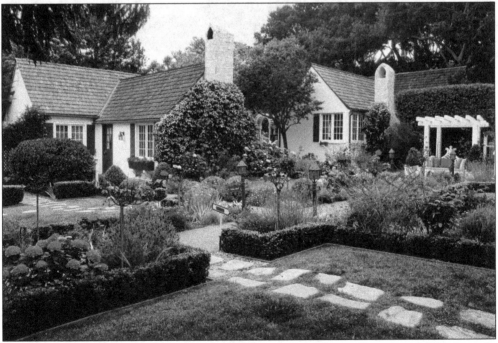

LINCOLN GREEN INN. Four Tudor-style Cotswold cottages make up this inn at 26200 Carmelo Street, built in the mid-1920s as the first visitor accommodation on Carmel Point. The cottages are surrounded by English gardens, and each has a name based on the legend of Robin Hood.

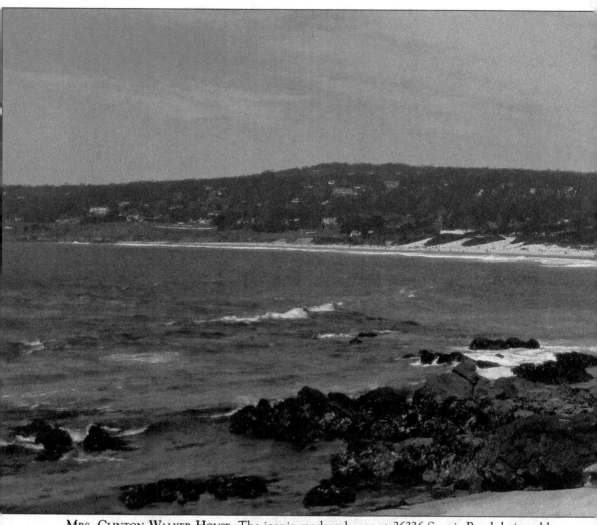

MRS. CLINTON WALKER HOUSE. The iconic modern house at 26336 Scenic Road designed by architect Frank Lloyd Wright was constructed in 1952. Before World War II, Wright had planned to construct four houses on the Monterey Peninsula with Jon Konigshofer as construction supervisor, though ultimately, this was the only one that was built. The house with its distinctive copper

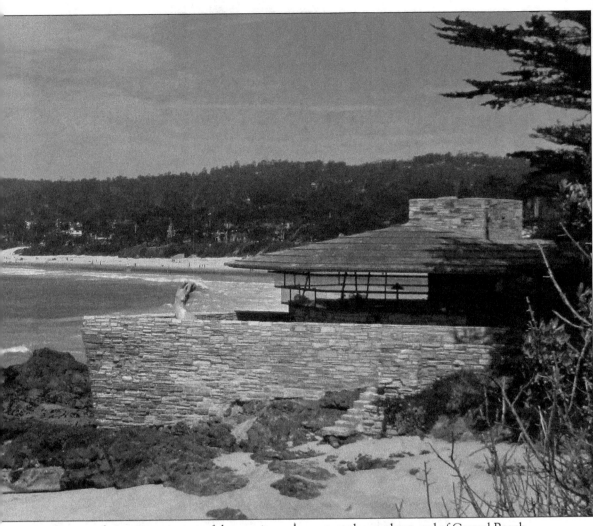

roof appeared as an organic part of the granite rock coast, at the southern end of Carmel Beach. Longtime local contractor Miles Bain was the builder. The 1959 movie *A Summer Place* with Sandra Dee and Troy Donahue was filmed in the house and surrounding beach.

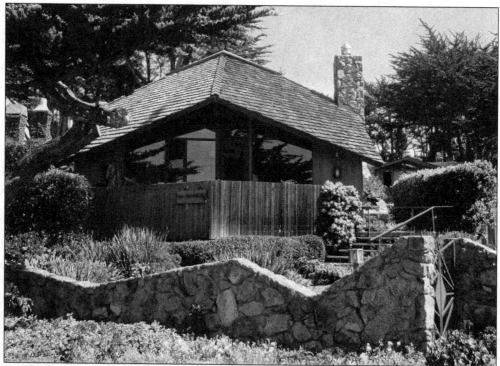

ESTHER M. HILL HOUSE. Russian-born architect and teacher Marcel Sedletzky created this unique home on Scenic Road 2NE of Santa Lucia Avenue in 1964. It combined geometric forms with natural materials from the Craftsman tradition in an open plan, as seen in mid-century Modern architecture, and represented the Third Bay Region style.

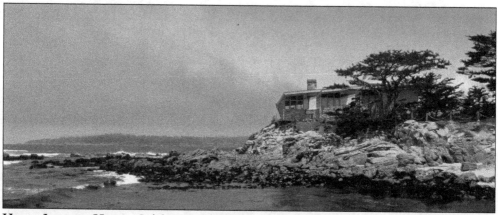

HENRY JOHNSON HOUSE. California architect and engineer Frank W. Wynkoop designed two houses on Carmel's coastline. The first was the legendary "Butterfly House" in 1952, at 26320 Scenic Road, which was his own residence. The second was this one, done the following year at 26200 Scenic Road. Its mid-century Modern Expressionist architecture was influenced by Frank Lloyd Wright's Organic design style.

Three

SOUTHWEST
GOLDEN RECTANGLE

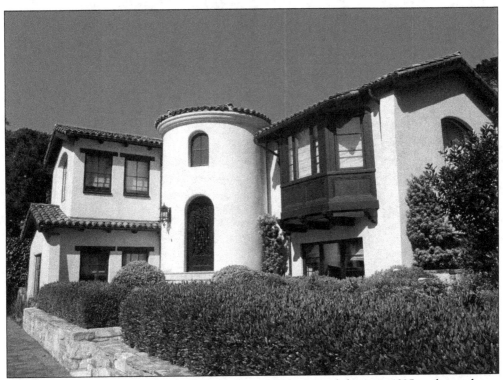

JESSE H. PAYNE HOUSE. M.J. Murphy built the Spanish Eclectic–style house in 1925 on the northwest corner of Carmelo Street and Seventh Avenue. It was constructed in a popular architectural revival style of the time, with design elements taken from the Mediterranean and Mexico. The Golden Rectangle is centrally located near the beach and downtown.

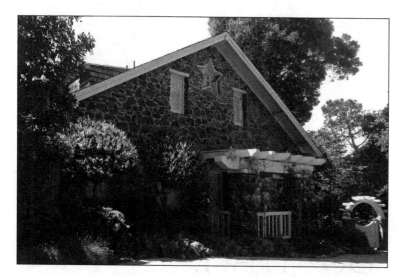

JOSEPHINE FOSTER HOUSE (STONEHOUSE INN). This Craftsman-style house 2W of Monte Verde Street on the south side of Eighth Avenue was built in 1906. The stonework was done by Ben Turner. In 1922, popular nationally syndicated cartoonist Gene Byrnes bought the home. It became an inn in 1946.

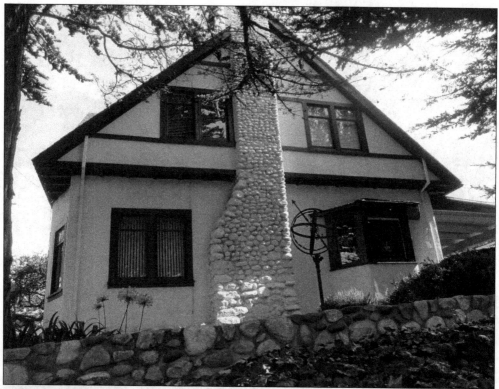

MACGOWAN-COOKE HOUSE. In 1905, architect Eugenia Maybury designed the Tudor Revival–style house 2E of San Antonio Avenue on the north side of Thirteenth Avenue. Ben Turner was the stonemason. Since 1908, it was the longtime home of writers and sisters Alice MacGowan and Grace MacGowan Cooke. Cooke's daughter Helen married prominent Carmel Highlands writer Harry Leon Wilson. Their daughter Charis later married famed photographer Edward Weston.

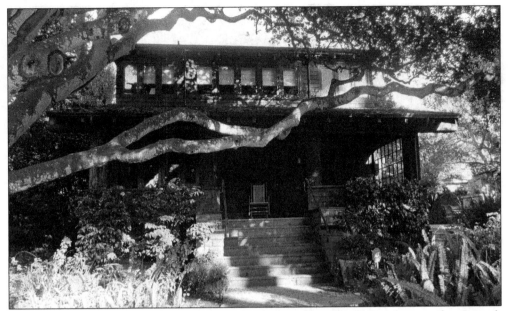

ARNOLD GENTHE HOUSE. San Francisco society photographer Arnold Genthe moved to Carmel-by-the-Sea in 1905 and designed his Craftsman-style home on Camino Real Street 2NE of Eleventh Avenue. He did pioneering work in color photography. In 1911, Genthe permanently relocated to New York City.

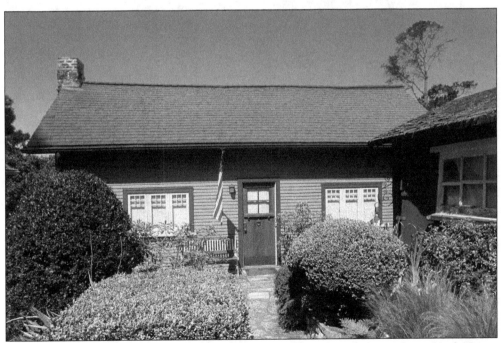

SINCLAIR LEWIS HOUSE. Delos Goldsmith built this vernacular cabin on Monte Verde Street 2NW of Ninth Avenue in 1905. Yale graduates and budding writers Sinclair Lewis and William Rose Benét rented it in 1909 while Lewis worked as a secretary for the MacGowan sisters. Years later, both men won Pulitzer Prizes for their writing.

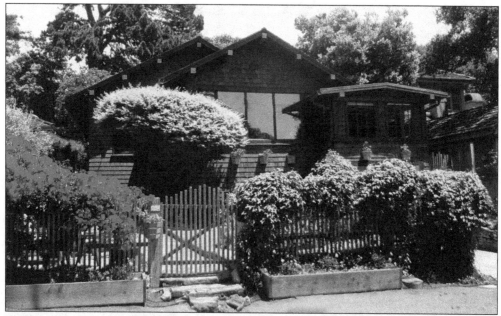

DR. VERNON KELLOGG HOUSE. Since 1906, this redwood Craftsman-style cottage on Camino Real Street 3SE of Seventh Avenue was the summer residence of the Stanford University zoology professor and his wife, Charlotte. It was part of Professors' Row. The Kelloggs took part in productions at the Forest Theater. Their daughter Jean became a Carmel artist.

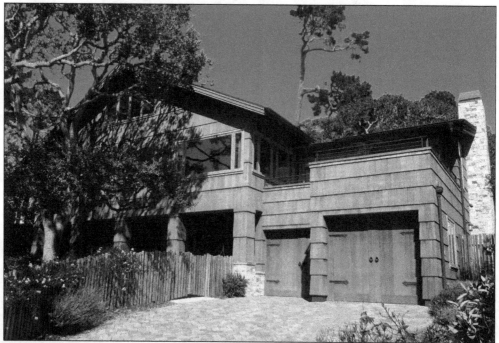

RUTH RICE HOUSE. The large, wood-shingled Craftsman-style house on Carmelo Street 2SE of Ocean Avenue was built around 1908. During the 1920s and 1930s, it was the site of many get-togethers among Bohemian artists, musicians, and writers, including author Lincoln Steffens, who lived nearby on San Antonio Avenue.

GUNNAR NORBERG HOUSE. Built in 1909, this Craftsman-style house on the southeast corner of Carmelo Street and Tenth Avenue was a wedding present for newlyweds Gunnar Norberg and Barbara Collins from the bride's parents in 1940. Barbara was an actress from the Barrymore family, and Gunnar, also an actor, was mayor of Carmel in the late 1970s.

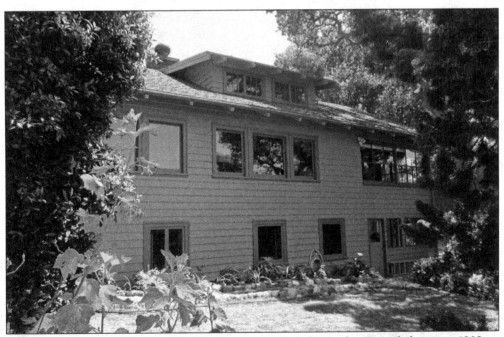

GEORGE F. BEARDSLEY HOUSE. M.J. Murphy constructed the Craftsman-style house in 1909 on the southwest corner of Casanova Street and Eighth Avenue. The Beardsleys were active in Carmel-by-the-Sea's early civic and cultural life. George was elected to the city's first board of trustees in 1916.

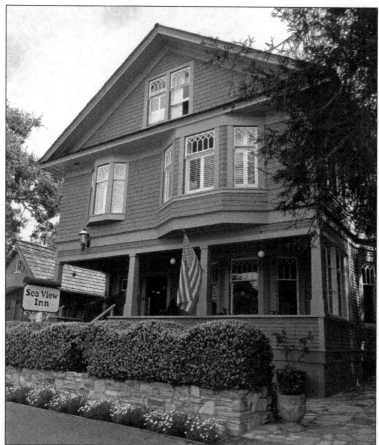

McDow-Jones House (Sea View Inn). The vernacular house with some Queen Anne and Colonial Revival touches was built on Camino Real Street 2NE of Twelfth Avenue around 1907 by M.J. Murphy. The Abbie McDow and Aimee Jones residence became a hotel in 1924 and has been a bed-and-breakfast inn ever since.

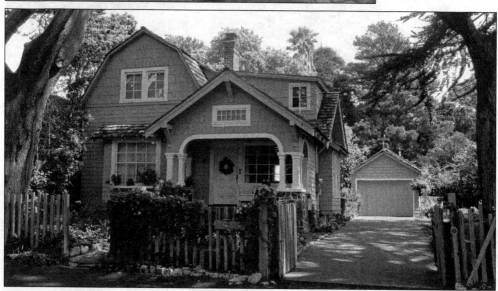

Leroy Babcock House. This eclectic two-story house on Camino Real Street 2SE of Twelfth Avenue combined the Craftsman and Shingle styles popular at the time, with both gambrel- and gable-style roofs. Builder Leroy Babcock constructed it around 1918 as his own home.

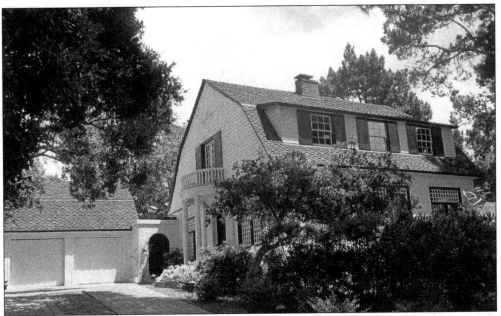

D.W. JOHNSON HOUSE. The Colonial Revival–style house with a gambrel roof on the northeast corner of Casanova Street and Seventh Avenue was extensively remodeled by M.J. Murphy in 1925 for Dewitt Wallace Johnson. He and his mother owned the Hotel Carmel. Johnson was later Carmel's first police and fire commissioner.

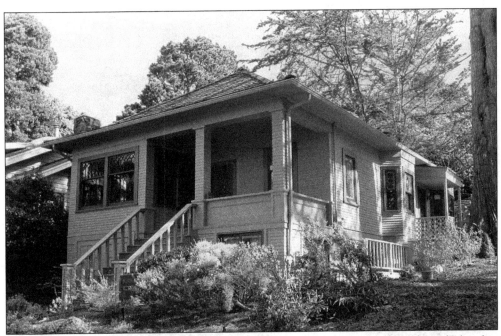

ENOCH LEWIS HOUSE. Enoch Lewis, his wife, and son Louis, a pioneering Carmel family, lived in this house on Monte Verde Street 2NE of Ninth Avenue. It was built in the vernacular, hipped row cottage style around 1906. Enoch later had a paint shop in downtown Carmel.

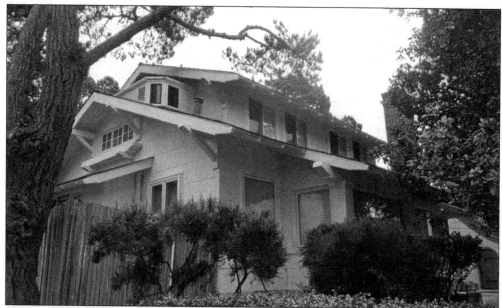

M.J. Murphy House (Above) and Office (Below). Around 1904, M.J. Murphy constructed this Craftsman-style house for his family on the southeast corner of Monte Verde Street and Ninth Avenue. He married his wife, Edna, that year, and they had four children. Over the years, Murphy added to the house, and by 1926, it had 23 rooms. He opened his contracting company, lumberyard, and building supply store in 1914. His rock-crushing operation began in Carmel Valley in 1924. Edna managed his businesses. During the early 1920s, Murphy was on Carmel's board of trustees. In 1922, he built his office directly next door to his residence on Monte Verde Street 2SE of Ninth Avenue. Designed in the Tudor Revival style, which was gaining popularity at that time, and used as a model home, it was one of the first in Carmel to have a stucco exterior.

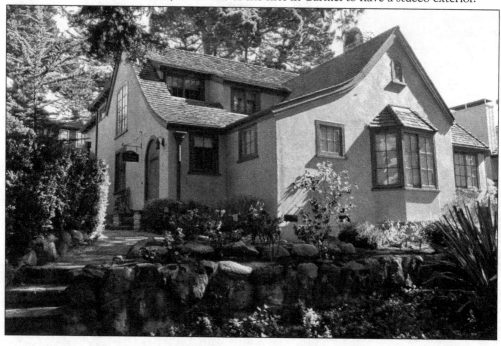

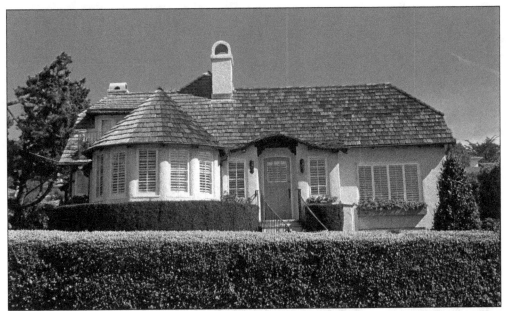

REV. GEORGE M. DORWART HOUSE. M.J. Murphy built the Tudor Revival–style house in 1926 on the southeast corner of San Antonio and Eighth Avenues. Reverend Dorwart was affiliated with the All Saints' Episcopal Church and also served on Carmel's board of trustees from 1920 to 1922, at the same time as Murphy.

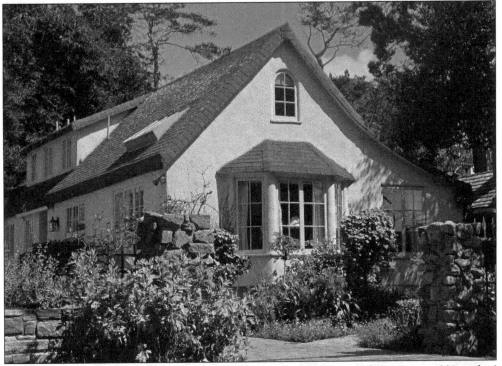

DR. H.R. GREEN HOUSE. This beloved house was voted one of Carmel's favorites in a 1992 readers' poll in the *Carmel Pine Cone*. The two-story Tudor Revival–style cottage was built by M.J. Murphy in 1927 on Camino Real Street 4SE of Tenth Avenue for a Palo Alto doctor.

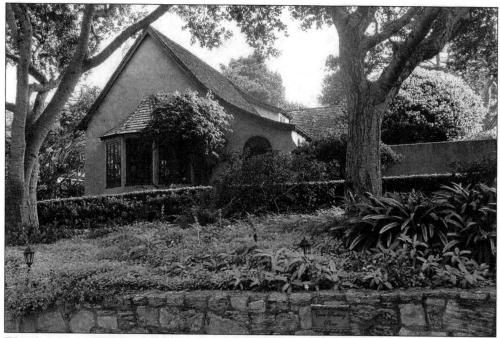

WHITNEY PALACHE HOUSE (EDGEMERE COTTAGES). Four neighboring houses in the Palache family compound were all built by M.J. Murphy. The first, a Tudor Revival–style house on San Antonio Avenue 2NE of Santa Lucia Avenue, is now a bed-and-breakfast inn. It was constructed in 1926 for Whitney Palache, whose father, James, made his mid-19th-century fortune in the East Bay Area through food imports, oil, and real estate development.

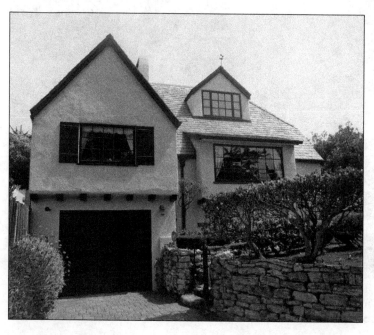

MARY ORRICK HOUSE. In 1928, M.J. Murphy built the second house, located on San Antonio Avenue 3SE of Thirteenth Avenue, for Whitney Palache's sister Mary. Mary had modeled the Tudor Revival–style English cottage on the 12-bedroom mansion in Pebble Beach she and her husband, eminent San Francisco attorney William H. Orrick, owned. Orrick also founded the private Cypress Point Golf Club in Pebble Beach in 1928.

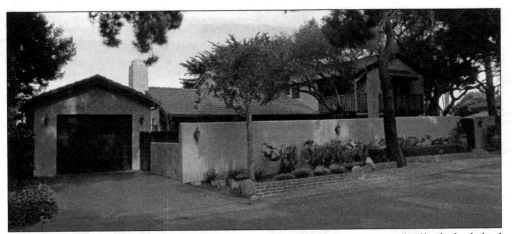

JOHN PALACHE HOUSE. The third house in the Palache family compound, all of which had interconnected interior gardens along with the first electric intercom system in Carmel, was on the southwest corner of Carmelo Street and Thirteenth Avenue. M.J. Murphy built it in the Spanish Eclectic Colonial Revival style in 1931 for Whitney's son John.

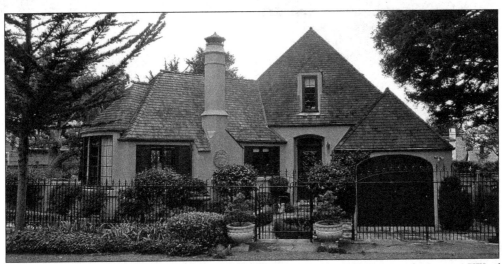

ELIZA PALACHE HOUSE. This two-story French Eclectic–style house on Carmelo Street 2SW of Thirteenth Avenue was constructed by M.J. Murphy in 1932. It resembled the farmhouses seen in Normandy. As the last of the four houses in the Palache family compound, it was built for Whitney's older sister Eliza.

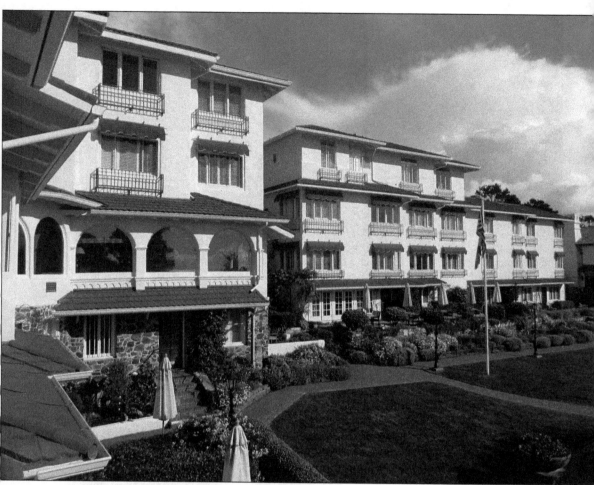

LA PLAYA HOTEL. Carmel's second oldest hotel originated in 1905 on the southwest corner of Camino Real Street and Eighth Avenue as San Francisco artist Chris Jorgensen's residence. In 1915, owner Agnes Signor made it a boardinghouse, named The Strand, and then enlarged it into a 20-guest room hotel in 1922. After a fire, M.J. Murphy did the reconstruction, and La Playa opened in 1925. Under the next owner, Signor's great-nephew Fred Godwin, who became Carmel's mayor in the late 1940s, designer Jon Konigshofer transformed and expanded the hotel, with a stucco exterior and 80 rooms, plus a dining room in 1940. Bud Allen, owner in the 1970s, the man Clint Eastwood credits for convincing him to run for mayor of Carmel, added the bar and the 10¢ Sunday martini special. In the early 1980s, the property was purchased and renovated by San Francisco's Cope family. La Playa became a Mediterranean Revival–style hotel with tile roofs and a pink exterior. It is known for its gardens, swimming pool, and wedding celebrations. With new ownership in 2011 and a face-lift, it was renamed La Playa Carmel.

La Playa Camino Real Street Entrance. Stonemason Benjamin Turner built the 25-foot-tall stone tower, which Jorgensen used as his art studio. Jorgensen's wife, artist Angela Ghirardelli, who had been one of his students, was the daughter of the founder of the famed San Francisco chocolate company.

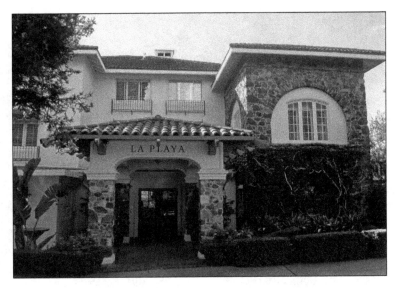

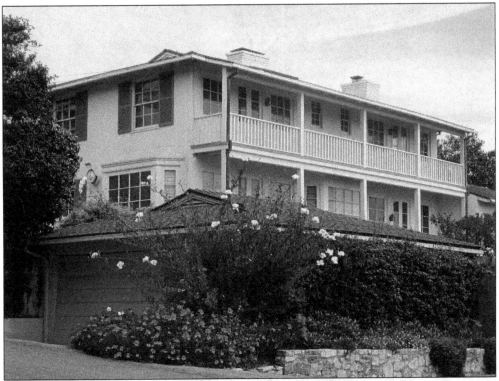

C. Fred Holmes House. Jon Konigshofer designed the Monterey Colonial–style house in 1940 as a Northern California rancher's vacation home on the southwest corner of Carmelo Street and Eighth Avenue. During his career, Konigshofer designed 150 homes and buildings in Carmel and Pebble Beach. The builder, Carl Daniels, had previously spent seven years on the construction of Hearst Castle.

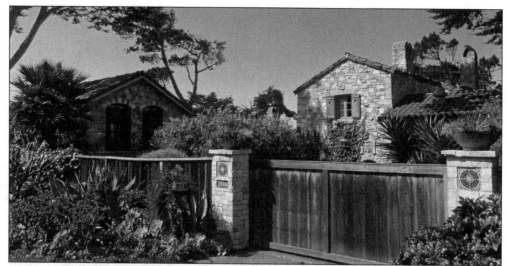

PHILIP AND MARIE GORDON HOUSE. This Spanish Eclectic–style house, with a coursed rubble Carmel stone exterior on San Antonio Avenue 3SW of Ninth Avenue, was built in 1922 for a Southern Pacific Railroad executive and his artist wife. Designed by San Francisco architect George F. Ashley and constructed by Lee Gottfried, it incorporated artifacts the Gordons brought back from Spain.

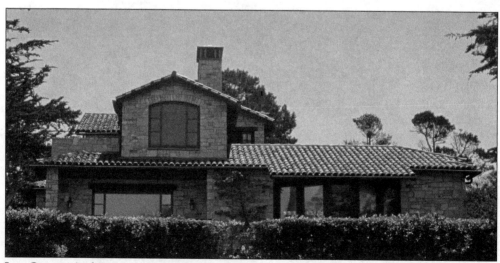

LAS ONDAS. Architects Swartz & Ryland designed a garage addition in 1933 to the house with a Carmel stone exterior and red tile roof on the southwest corner of San Antonio and Ninth Avenues. It was the residence of actor and film director Clint Eastwood during the 1980s and 1990s, including during his one term as mayor of Carmel from 1986 to 1988.

REGINALD MARKHAM HOUSE. In 1927, designer and builder Frederick Bigland constructed an unusual Spanish Eclectic–style house with a Moorish-inspired look on the southwest corner of Casanova Street and Eleventh Avenue. The flat roof and small windows with grillwork resembled design features found in the buildings of North Africa.

H. MARKHAM HOUSE. This International-style house with a smooth, stucco exterior and flat roof on the northeast corner of Dolores Street and Thirteenth Avenue was built in 1936. In Carmel, it is the earliest residential example of this architectural style, which was rarely used.

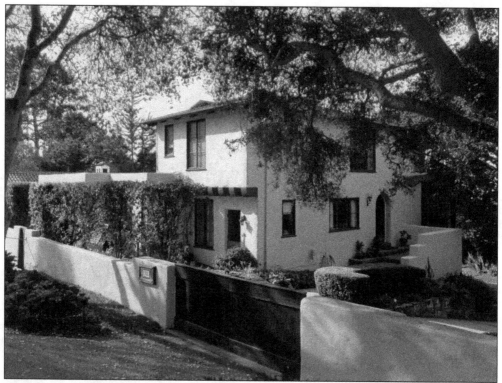

John B. Adams House. M.J. Murphy constructed the one-and-two-story Spanish Eclectic–style house in 1928 on Carmelo Street 2NW of Seventh Avenue. The varying heights of the structure are design features that resemble the architecture seen in Spanish hill towns.

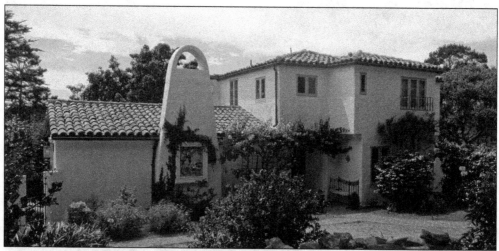

Gregory H. Illanes House. In 1928, Frederick Bigland designed this two-story Spanish Colonial Revival–style house on Carmelo Street 2NW of Tenth Avenue for the New York shipping executive. Many of Carmel's larger homes were constructed around the 1920s and 1930s, often as vacation homes for the well-to-do.

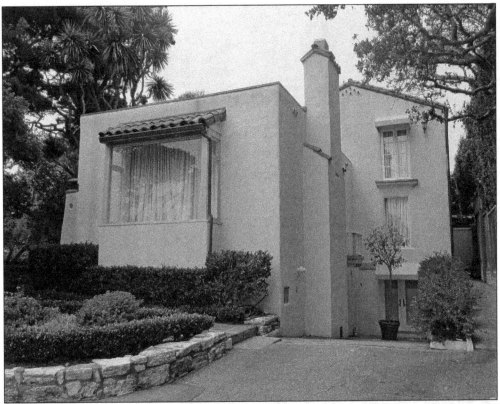

LAURA FENNER HOUSE. The two-and-three story Spanish Eclectic–style house was designed and built on the northeast corner of Camino Real Street and Fraser Avenue in 1923 by L.A. Lang & Sons. John Steinbeck's younger sister, Mary Steinbeck Dekker, lived there during the 1940s and 1950s.

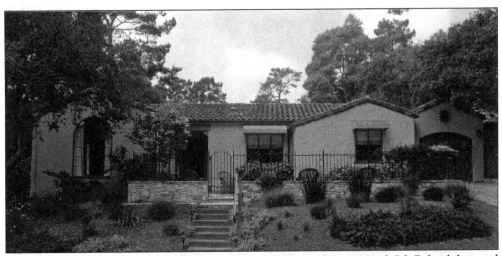

COMMUNITY CHURCH RECTORY. Fresno-based architects Fred Swartz and C.J. Ryland designed this Spanish Eclectic–style residence at the northeast corner of Eleventh Avenue and Lincoln Street. It was constructed by Miles Bain in 1930. Most notably, Swartz & Ryland designed Carmel's Sunset School Auditorium in 1931, which is in the National Register of Historic Places.

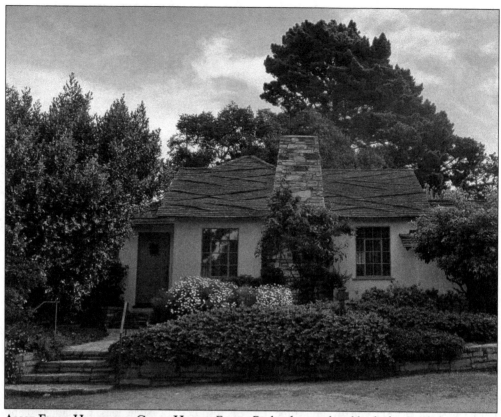

ALICE ELDER HOUSE AND GUEST HOUSE. Ernest Bixler designed and built this English Cottage–style house in 1932 on Carmelo Street 4SE of Tenth Avenue. The wood shingles of the roof were laid in a pattern to resemble thatch, while the large main chimney was covered with battered Carmel stone.

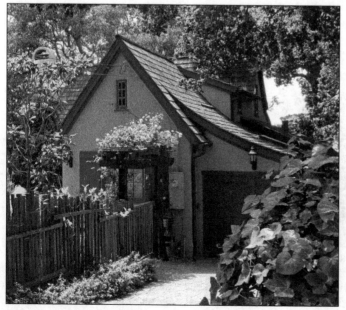

ANNE WINSLOW HOUSE. M.J. Murphy constructed the Tudor Revival–style house on Dolores Street 2NW of Thirteenth Avenue in 1925. Winslow was one of Carmel's greatest philanthropists and funded many local organizations, including the Red Cross, Carmel Woman's Club, and Monterey Peninsula Community Hospital.

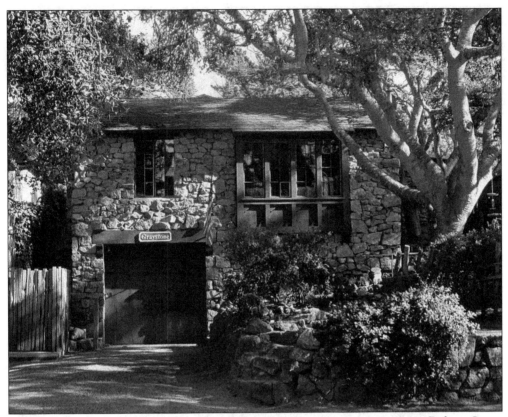

BLISS-HUBBELL HOUSE. The vernacular residence with a granite stone veneer on Dolores Street 2NE of Twelfth Avenue was designed and built by George Whitcomb and Miles Bain in 1928 for two retired schoolteachers. In the late 1920s, Whitcomb and Bain worked together in Carmel in the construction business.

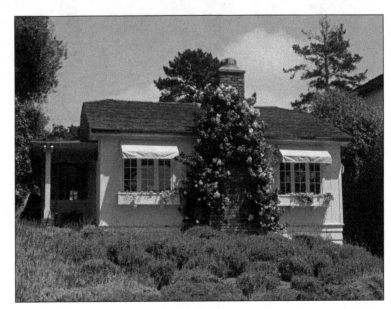

BOSTICK CASANOVA STREET COTTAGE. Builder Maynard McEntire constructed this bungalow on Casanova Street 3SE of Eighth Avenue in 1938 for local realtor and author Daisy Fox Desmond Bostick. She and Dorothea Castelhun cowrote the 1925 book *Carmel At Work and Play.*

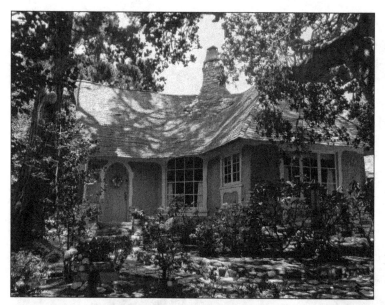

MÄRCHEN HAUS. One of Hugh Comstock's larger Tudor Storybook–style houses was constructed in 1926 on the northeast corner of Dolores Street and Eleventh Avenue. It had many of the familiar design elements Comstock often used. The large, irregularly shaped Carmel stone chimney was a distinctive feature.

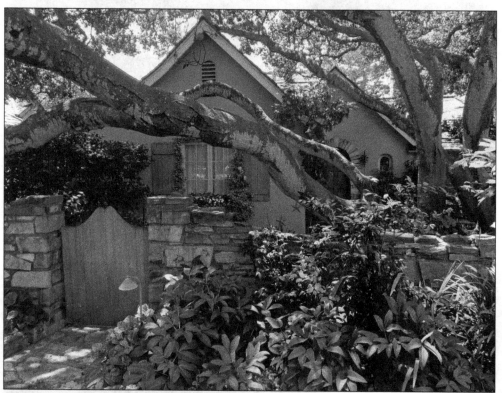

MRS. GLENN MYERS HOUSE. Ernest Bixler designed and built the Tudor Revival–style house on Carmelo Street 3NW of Thirteenth Avenue in 1930. A San Francisco philanthropist, art and music patron, and supporter of California's Carmelite monasteries, Noël Sullivan lived there in the 1930s. He lent the house to his friend, poet Langston Hughes, who wrote a collection of short stories there during 1933.

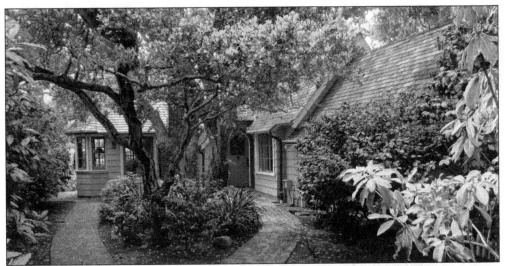

ETHEL ENGLAND HOUSE. This French Eclectic–style house on Casanova Street 2NW of Thirteenth Avenue was designed in 1931 by Guy Koepp. Hugh Comstock was the builder. The steep-pitched, wood-shingled roof was reminiscent of 18th-century farmhouses in Burgundy. As a World War I veteran, Koepp had seen Europe's rural architecture firsthand.

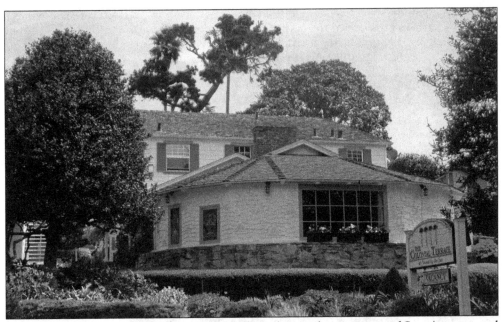

COLONIAL TERRACE INN. The 26-room hotel on the northeast corner of San Antonio and Thirteenth Avenues consists of six one-and-two story buildings constructed predominantly during the 1930s in the Colonial Revival Georgian architectural style. Some of the construction work was done by Ernest Bixler.

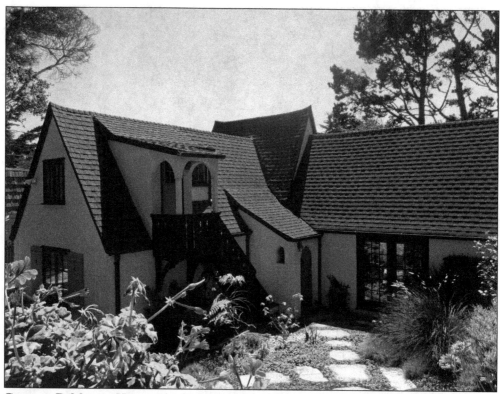

GARFIELD D. MERNER HOUSE. This Tudor Revival–style house on Carmelo Street 2SW of Seventh Avenue sits below the street level. Built in 1924, it was most likely the work of Bay Area architect George McCrea, as it resembled the house he designed for Dr. Hermann Spoehr in Carmel in 1922. Merner was a businessman, art patron, world traveler, and philanthropist who, with his wife, Delight, founded the Allied Arts Guild in Menlo Park in 1929.

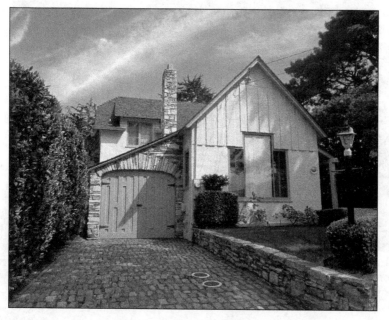

LA FRENZ HOUSE. The modest Tudor Revival–style English cottage on San Antonio Avenue 4NE of Eighth Avenue reflected the austerity of the Great Depression. It was designed and constructed in 1931 by Ernest Bixler for two Carmel shop owners, husband and wife Adolph La Frenz and Hallie Samson, who also owned several rental properties in town.

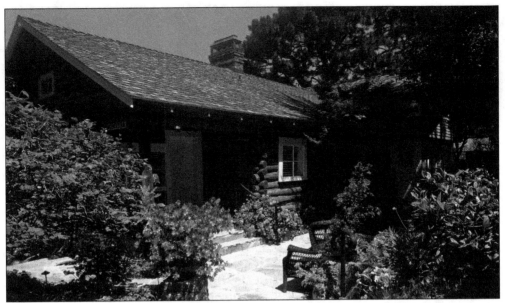

Log Haven (Carmel Cottage Inn). This simple log cabin 2E of San Antonio Avenue on the north side of Eighth Avenue was built around 1907, one of the few of its kind still remaining. In the early 1940s, Ernest Bixler constructed four neighboring residences for Adolph La Frenz, who rented all five as Cottages by the Sea.

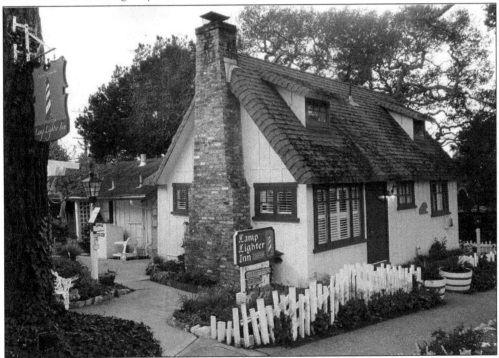

Peter Pan Court (Lamp Lighter Inn). The three Tudor-style guest units on the southeast corner of Ocean Avenue and Camino Real Street were built by owner Maude Arndt in the mid-1920s. Arndt, who had a fondness for the fairy tale character Peter Pan, was one in a long line of Carmel's eccentric residents, as well as female builders.

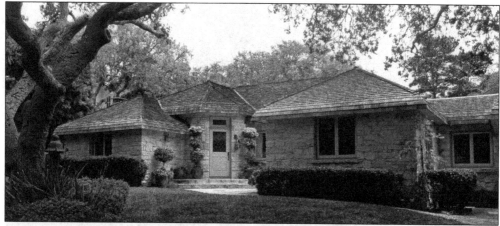

La Von "Lee" Gottfried House. One of Carmel's busiest builders from the 1920s and 1930s designed and constructed his family residence in 1921 on Dolores Street 7SE of Thirteenth Avenue. The vernacular-style cottage resembled ones seen in the European countryside. Gottfried, a World War I veteran, moved to Carmel shortly after his service in Europe. He was on the board of trustees in the late 1920s.

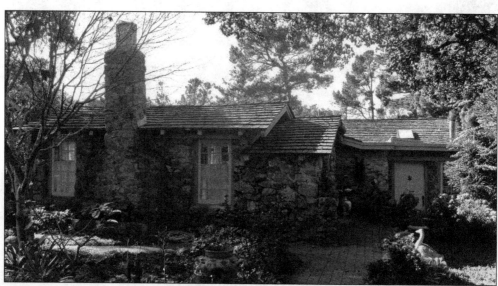

Perry Newberry Stone House. The Bohemian journalist, political activist, and preservationist who served in World War I constructed the eclectic stone cottage in 1923 on Dolores Street 5SW of Twelfth Avenue. Newberry managed to find time to design and build cottages in Carmel during the 1920s and 1930s.

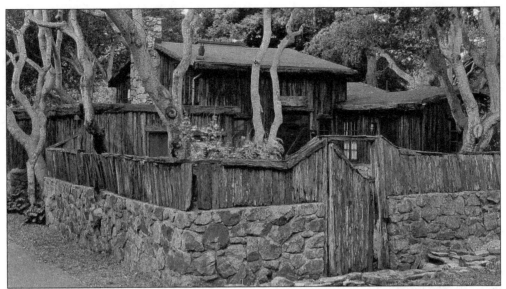

MRS. J.S. CONE HOUSE. This rustic bungalow on the northwest corner of Monte Verde Street and Thirteenth Avenue was clad in a rough, redwood-bark exterior. It was designed in 1922 by a creative and artistic woman, Mrs. Cone, and constructed by Lee Gottfried.

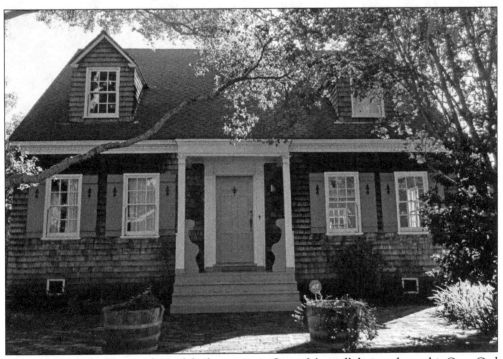

LOUISE P. MURPHY HOUSE. One of the houses artist Laura Maxwell designed was this Cape Cod Revival–style residence in 1931 on the northeast corner of Camino Real Street and Twelfth Avenue. Her husband, naval captain William Maxwell, was mayor of Carmel in 1922.

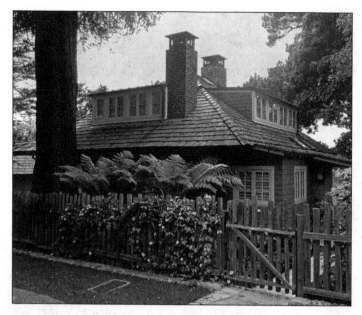

HOLIDAY HOUSE. Around 1905, the large American Foursquare–style house was designed and also likely built by Stanford University mechanical engineering professor Dr. Guido Marx, who cofounded the School of Engineering. It was his summer residence, part of Professors' Row, on Camino Real Street 2NW of Seventh Avenue. M.J. Murphy remodeled it in 1937. Since the 1920s, it had been run as a longtime inn, but it was reverted to a residence some 80 years later.

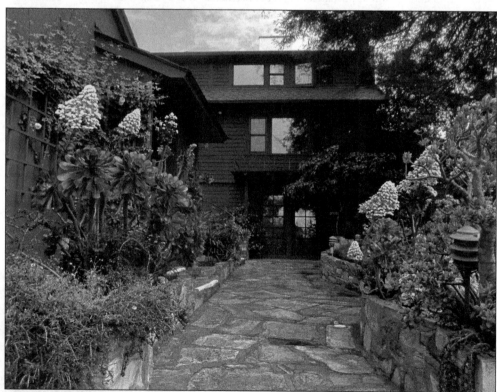

THE HOMESTEAD. The house, originally constructed on the northeast corner of Lincoln Street and Eighth Avenue, was altered into a boardinghouse in the 1930s and then an inn in the mid-1940s. Clint Eastwood bought it in 2000 and renovated the 12 rooms. The Homestead is a sister property to Eastwood's Mission Ranch.

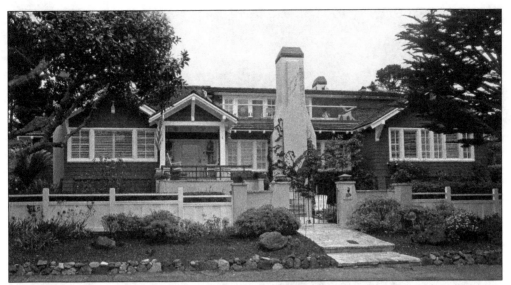

COL. HAROLD MACK HOUSE. In 1907, San Francisco banker Col. R.D. Frye bought several lots and built a large Craftsman-style house on the northeast corner of Carmelo Street and Thirteenth Avenue. In 1949, Col. Harold Mack, a retired New York stockbroker, bon vivant, and patron of the arts who lived to the age of 100, made it his longtime home.

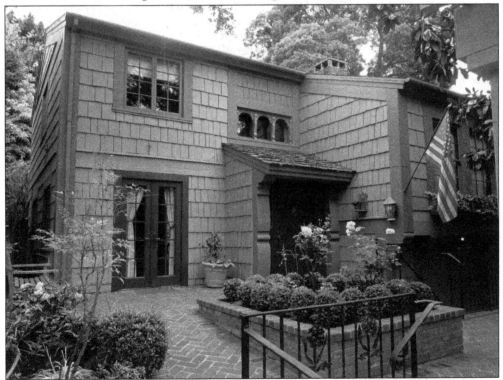

DR. WILLIAM MCCABE HOUSE. This vernacular, Scandinavian-inspired-style house was built for a Stanford University professor in 1940 on Casanova Street 5NE of Santa Lucia Avenue. Constructed by Miles Bain, it was designed by Swedish architect Lennart Palme, known for the historic mansion Vikingsholm, which he designed at Lake Tahoe.

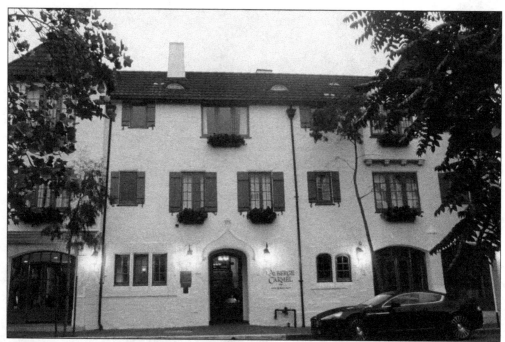

SUNDIAL COURT (L'AUBERGE) FRONT (ABOVE) AND COURTYARD (BELOW). San Francisco architect Albert Farr designed the three-story, 16-unit apartment building around an open inner courtyard in 1929, in a Medieval European architectural style. Located on Monte Verde Street 2NE of Seventh Avenue, M.J. Murphy constructed it in 1930. Allen Knight commissioned the construction, on land his family owned, after his travels through Europe in the 1920s. His inspiration came from a Czechoslovakian hotel. Knight was one of many colorful and offbeat Carmel residents—a musician, maritime enthusiast, and mayor in the early 1950s. It became the Sundial Lodge Hotel, and another free-spirited Carmel character, Howard "Bud" Allen, owned it from 1969 to 1983. In the early 2000s, under new ownership, the 20-room boutique hotel was renamed L'Auberge, part of Relais & Châteaux. It retains its old world ambiance and features the 12-seat Aubergine restaurant with award-winning chefs.

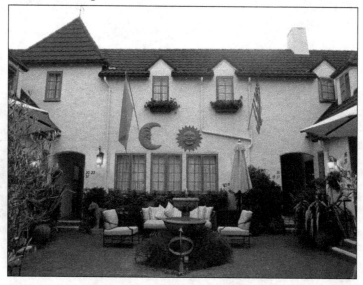

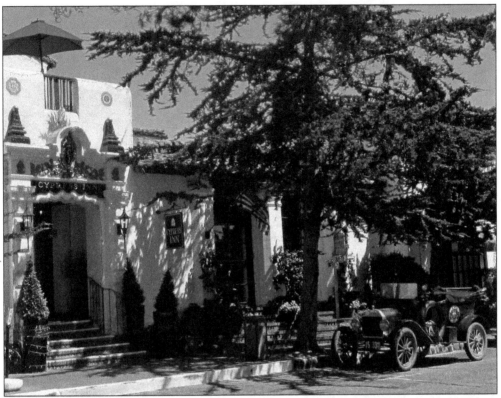

LA RIBERA HOTEL (CYPRESS INN) ENTRANCE (ABOVE) AND SIDE (BELOW). Inspired by their travel to Spain, Oakland architects Roger Blaine and David Olson, who did much work in Santa Barbara in the 1920s, designed the hotel on the northeast corner of Lincoln Street and Seventh Avenue in 1929. The Spanish Eclectic Mediterranean–style building included a Moorish tower, decorative tiles, and a garden courtyard. A two-story addition was done by San Francisco architect Gardner Dailey in 1949. Known as Cypress West in the 1960s, it was renamed Cypress Inn and has been co-owned by actress, singer, and animal rights advocate Doris Day since the mid-1980s. With 44 guest rooms, Cypress Inn is renowned for its pet friendliness, with doggie menu items and "Yappy Hour," along with afternoon high tea and classic cocktails from a bygone Hollywood era at Terry's Restaurant and Lounge.

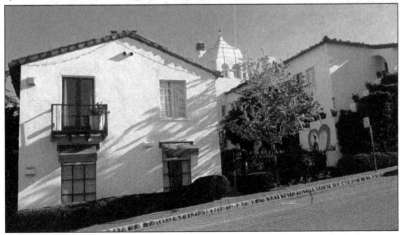

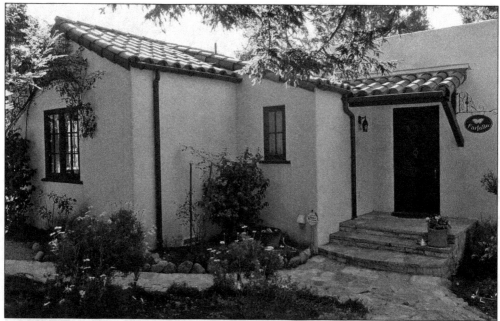

ETHEL P. YOUNG HOUSE. As a contractor not yet an architect, Robert Stanton, who was married to Virginia Young, designed this Spanish Eclectic–style house on the southwest corner of Carmelo Street and Eleventh Avenue. It was constructed for his mother-in-law, Ethel Young, as a rental property in 1926.

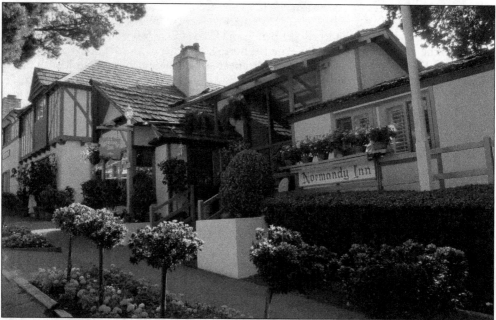

NORMANDY INN. In 1925, Robert Stanton built his office in downtown Carmel. He began the adjacent Tudor Revival–style hotel on the southwest corner of Monte Verde Street and Ocean Avenue in 1936, which his mother-in-law owned. Construction was by Frederick Ruhl of San Francisco's Dowsett-Ruhl Contractors. Ruhl was the main builder in Pebble Beach. Through the early 1960s, Stanton expanded the hotel with many additions to the French Norman Chalet theme.

NORMAN REYNOLDS HOUSE. Robert Stanton moved to Southern California later in the 1920s, where he worked for renowned architect Wallace Neff. The two developed a prefabricated house: the "Honeymoon Cottage." In the mid-1930s, after his return to Carmel with an architectural degree, Stanton built his version of the prefab house on the northwest corner of Dolores Street and Eleventh Avenue in 1937.

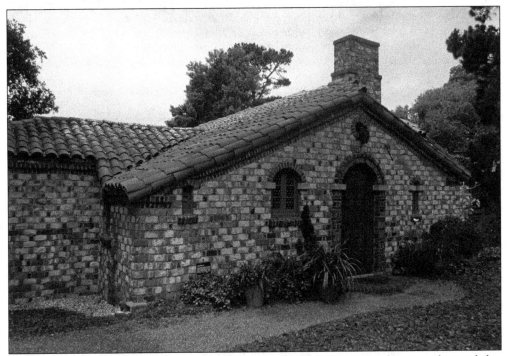

CHARLES SUMNER GREENE STUDIO. The noted Southern California architect—who, with his brother Henry Mather Greene, was known for Arts and Crafts–style architecture—moved to Carmel in 1916. He designed his eclectic Craftsman-style studio on Lincoln Street 4SW of Thirteenth Avenue in 1923, where he worked until his death in 1957. It was made with bricks and tiles reused from other buildings and projects.

JOHN GALEN HOWARD HOUSE. In 1907, prominent Bay Area architect John Galen Howard built a one-room beach cottage on Monte Verde Street 2SW of Thirteenth Avenue. Howard founded University of California, Berkeley's School of Architecture and designed many of the buildings on campus. Under later owners, additions were made to the house, including those done by Hugh Comstock in 1946.

MRS. B.C. BOWMAN HOUSE. In 1937, Hugh Comstock built the one-story house on the southwest corner of Carmelo Street and Tenth Avenue out of adobe brick he developed. Comstock experimented with the manufacture of a more durable adobe brick, a building material from California's Spanish and Mexican eras, which ultimately led to his invention of Post-Adobe, a waterproof brick made of emulsified asphalt.

Four

SOUTHEAST
CARMEL MISSION AND 80 ACRES TRACT

GERTRUDE S. EELLS HOUSE. The large Spanish Eclectic–style house sits on several lots of land first owned by University of California, Berkeley School of Law dean George Boke, one of Carmel's summer residents since 1907. Located on the northwest corner of San Carlos Street and Santa Lucia Avenue, the residence was constructed in the 1920s and expanded by M.J. Murphy in 1928.

MISSION ORCHARD HOUSE (ABOVE) AND MACHADO HOUSE (BELOW). This adobe house at 3100 Rio Road began as a lean-to against a garden wall at the Carmel Mission sometime after 1774. Artist Jo Mora expanded the structure in 1921, and it became a popular restaurant during the 1920s: the Mission Tea House. In the 1940s, Sir Harry Downie, who restored the Carmel Mission, did restoration work on the house. The Catholic Church now owns the property. The red vernacular barn was built in 1881 by Christiano Machado, a member of a leading Portuguese whaling family centered at Point Lobos, situated on the coast a few miles south of Carmel. Some of the construction materials had been taken directly from the Carmel Mission. Machado was the mission orchardist from 1877 to 1914.

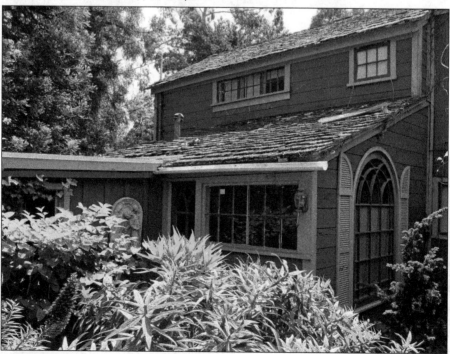

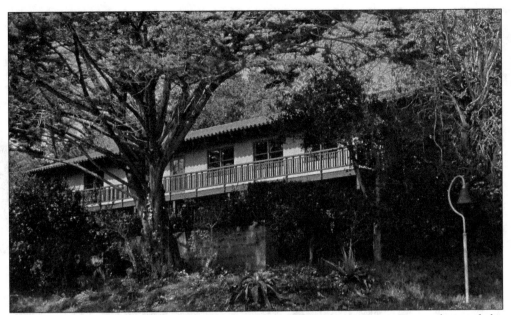

MARIA ANTONIA FIELD HOUSE. San Francisco Bay Area architect Denis Beatty designed the Monterey Colonial–style house at 2957 Santa Lucia Avenue in 1959. Field, author of *Chimes of Mission Bells*, was a member of the Munras family, one of the oldest founding families of Monterey. Upon her death in 1962, she was buried at the Carmel Mission Cemetery.

COL. HENRY L. WATSON HOUSE. The three-story Spanish Eclectic–style house was constructed on the northeast corner of Torres Street and Eleventh Avenue in 1925 for the West Point graduate and aviation pioneer. Later, for nearly four decades, it was the home of widowed English countess Claude Kinnoull, a world traveler, artist, philanthropist for Catholic causes, and major benefactress of the SPCA for Monterey County.

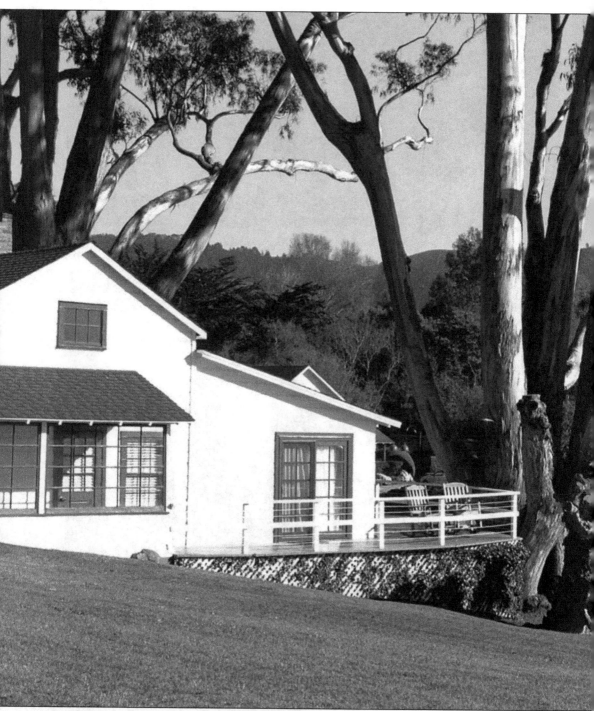

MISSION RANCH. The historic dairy and ranch on 22 acres at 26270 Dolores Street dates back to the mid-1800s. Near the Carmel Mission and Carmel Bay, it has views of the Santa Lucia Mountains, Point Lobos, and Carmel River State Beach. The open meadowland has grazing sheep. Over the decades, Mission Ranch went through many transformations: it was a private club, an officers' club during World War II, and a dance hall and bar. In the 1950s, while in the Army and

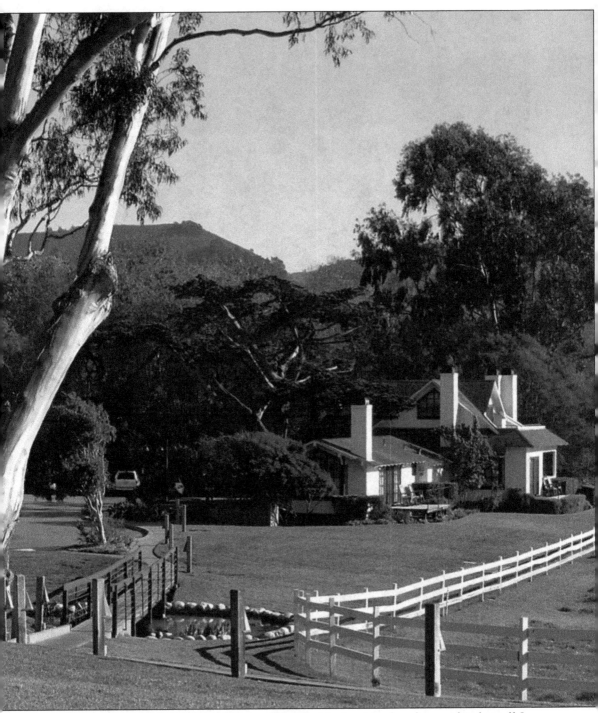

stationed at nearby Ford Ord, Clint Eastwood would visit the piano bar there on his days off. In 1986, the same year he was elected mayor of Carmel, Eastwood bought the property and saved it from demolition. Through the 1990s, he restored it as a 31-room hotel. The old creamery became the restaurant with a piano bar, and it serves classic American cuisine.

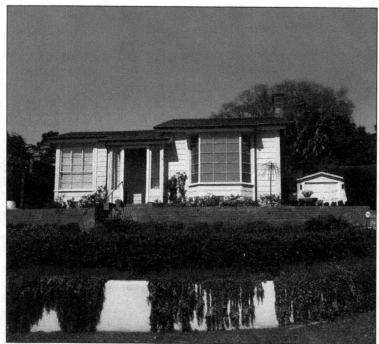

DR. EMMA POPE HOUSE. Architect Julia Morgan designed this Minimal Traditional–style house at 2981 Franciscan Way in 1940 on a hillside overlooking the Carmel Mission. It was for her former University of California, Berkeley classmate Dr. Emma Pope, whose daughter Virginia later lived next door and was married to Keith Evans, Carmel's mayor in the early 1940s.

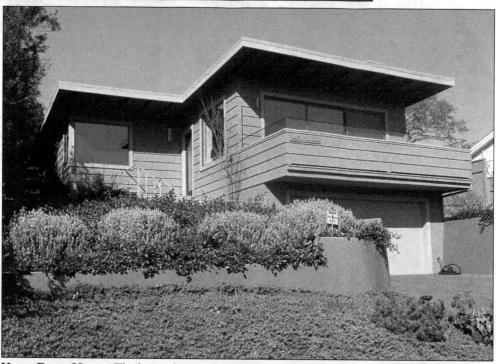

KEITH EVANS HOUSE. The house designed in 1948 by Jon Konigshofer in the Second Bay Region style at 2969 Franciscan Way is the best remaining example of Konigshofer's Hillside House, which he trademarked. It fit the trend and demand for affordable postwar housing, as it used modern, prefabricated materials and had a flat roof to keep costs down. It also had Craftsman features in its design. These homes were practical for Carmel's narrow, sloped lots.

GARDNER A. DAILEY HOUSE. The San Francisco architect designed his vacation home 2E of Forest Road on the south side of Ocean Avenue in 1945 in the Second Bay Region style. Dailey's connections to the Monterey Peninsula began in the 1930s, when he reviewed plans for Samuel F.B. Morse's Del Monte Company in Pebble Beach to make sure the residences fit the mandatory Spanish Eclectic architectural style requirement of the time.

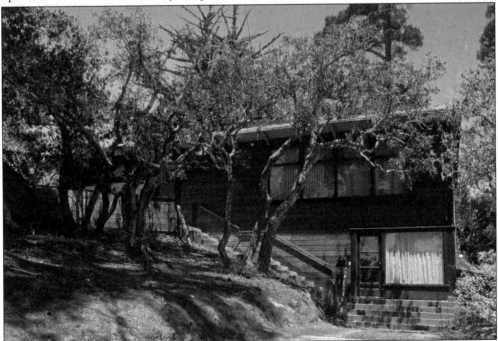

ROBERT A. STEPHENSON HOUSE. The longtime Carmel architect designed his residence at the northeast corner of Forest Road and Eighth Avenue in 1949. It was built in the American International–Second Bay Region style, with natural redwood siding and glass ribbon windows. Stephenson was active in local classical music organizations and served on the Carmel City Council and Planning Commission.

MILLS HOUSE (ABOVE) AND WALKER SPEC HOUSE (BELOW). Architect Mark Mills, a student of Frank Lloyd Wright at Taliesin West from 1944 to 1948, designed two adjacent houses financed by Mrs. Clinton Walker. The Mills House on the northeast corner of Mission Street and Thirteenth Avenue was built in 1952 with A-frame construction and a mitered glass skylight along the roof ridge line. The second house, constructed in 1953 at 2W of Junipero Street on the north side of Thirteenth Avenue, had horizontal clapboard siding and an open deck. Both were in the Organic-Wrightian style and featured unique "desert masonry" concrete walls. Mills was known for his use of geometric-design shapes along with natural materials to fit into the surrounding environment. He lived and worked in Carmel from the mid-1950s until his death in 2007. Many of his 70 distinctive projects were built on the Monterey Peninsula.

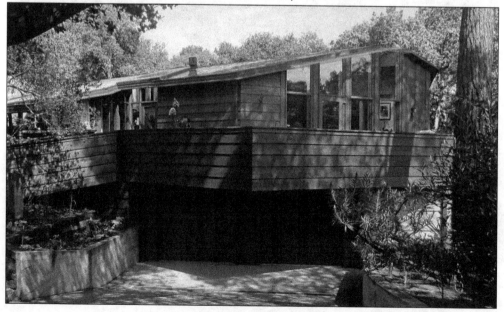

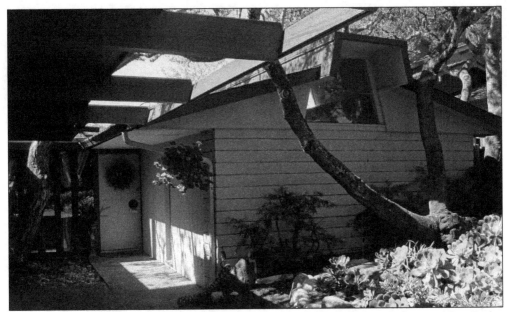

MR. AND MRS. WILLIAM JUNK HOUSE. In 1965, Mark Mills designed this residence on San Carlos Street 3SW of Thirteenth Avenue in the Organic-Wrightian style. It had an unusual trapezoidal-shaped glass skylight atrium that ran through the length of the house. It was constructed by the firm Helm-Savoldi, known for custom homes and work with designers Jon Konigshofer, Henry Hill, and Walter Burde.

VIVIAN HOMES II. Bay Area architect Henry Hill designed the house in the Second Bay Region style in 1963, with architectural partner Jack Kruse. It was located on a triangular-shaped lot with a steep grade on the southeast corner of Torres Street and Ninth Avenue. During their careers as a team, Hill and Kruse built 500 structures, some award-winning, with Hill as designer and Kruse as structural advisor. Later, Hill served on Carmel's planning commission.

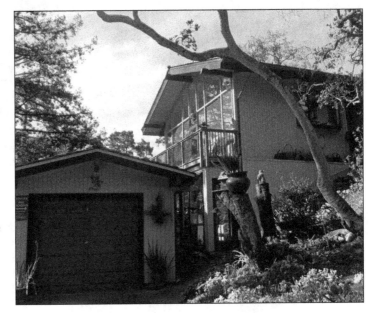

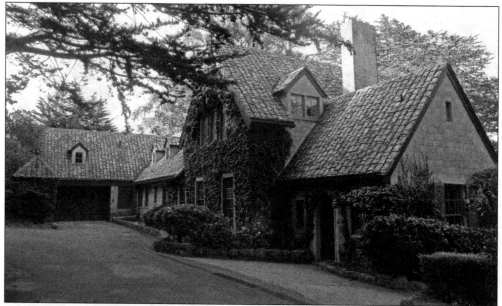

FLANDERS MANSION. The rugged Tudor Revival–style mansion made of interlocking concrete blocks at 25800 Hatton Road was constructed in 1925. Designed by San Francisco architect Henry Higby Gutterson, known for dozens of stately houses in the St. Francis Wood neighborhood, it was built by Frederick Ruhl. In 1972, the City of Carmel bought the house, now in the National Register of Historic Places, and added 32 surrounding acres as the Mission Trail Nature Preserve.

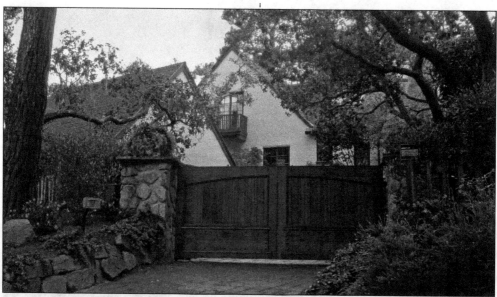

DR. HERMAN A. SPOEHR HOUSE. East Bay Area architect George McCrea designed the Tudor Revival–style house 3S of Mountain View Avenue on the west side of Crespi Avenue in 1922, with M.J. Murphy as the contractor. Professor Spoehr was a pioneering plant scientist who, during the 1920s and 1930s, worked for and later directed the Carnegie Institute's Coastal Laboratory in Carmel.

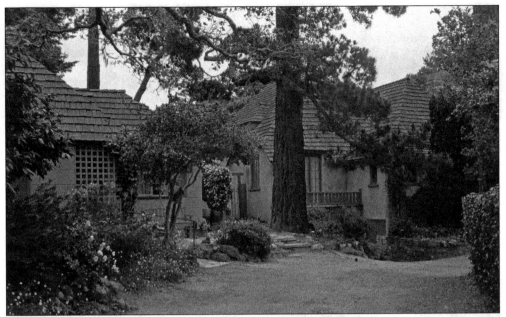

Maj. Ralph A. Coote House. The residence with Tudor and English Arts and Crafts–style influences on Santa Fe Street 4SE of Eighth Avenue was designed and built by Hugh Comstock in 1934 for the English baronet. Sir Coote sold his family's 600-acre estate in Ireland, Ballyfin, in 1928. He was an art patron and member of the Carmel Art Association.

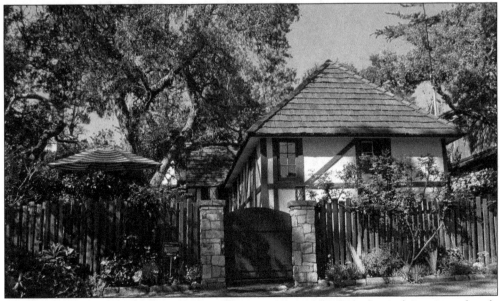

Nelson-Krough Cottage. In 1926, Hugh Comstock designed the Tudor Revival Continental–style residence located 3E of Santa Fe Street on the north side of Eighth Avenue. The cottage had design features that resembled those found in Medieval English architecture. During this time period, architectural revivalism was popular, notably the European styles.

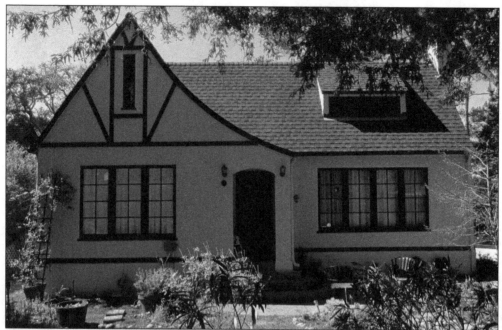

ROSS E. BONHAM HOUSE. Builder George Whitcomb constructed the Tudor Revival–style house in 1926 on the southwest corner of San Carlos Street and Twelfth Avenue. Ross Bonham was mayor of Carmel in the late 1920s, during an important era when the future character of the town was defined, with residential interests taking precedence over commercial ones.

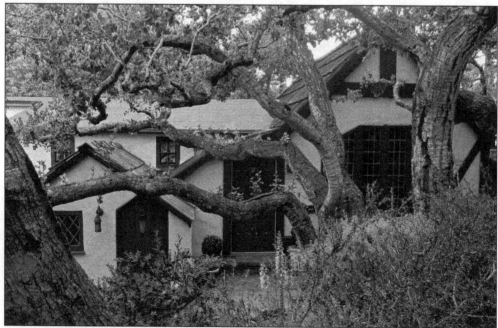

FREDERICK BIGLAND HOUSE. The English builder and craftsman constructed his Tudor Revival–style residence in 1926 on Mountain View Avenue 3SW of Santa Fe Street. Bigland arrived in California in the 1920s. His daughter Mary later married attorney Eben Whittlesey, who was Carmel's mayor in the early 1960s.

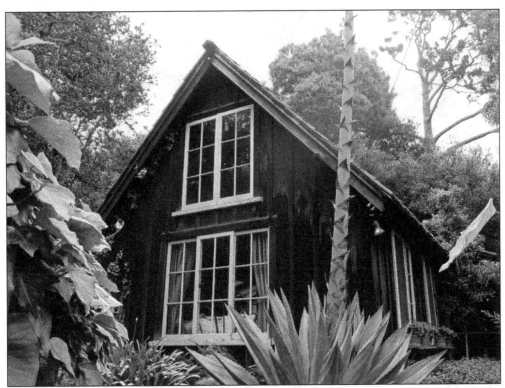

JACOB W. WRIGHT HOUSE (NO. 2). This vernacular cottage was built for a retired newspaperman and his wife on Santa Fe Street 2NE of Eighth Avenue. George Whitcomb constructed it in 1931 for Wright, who operated a private printing company, The Press in the Forest. Miles Bain, Whitcomb's building partner, did additional work in the 1930s.

JOHAN HAGEMEYER HOUSE (FOREST LODGE). In the early 1920s, the Dutch-born photographer and agriculturalist bought a triangular parcel of land on the southwest corner of Ocean Avenue and Torres Street. A cottage, guest studio, and studio-workshop were built and later altered by Hazel Watrous and George Whitcomb. Photographer Edward Weston rented the studio in the late 1920s. Following World War II, when Hagemeyer left for the Bay Area, the property became an inn.

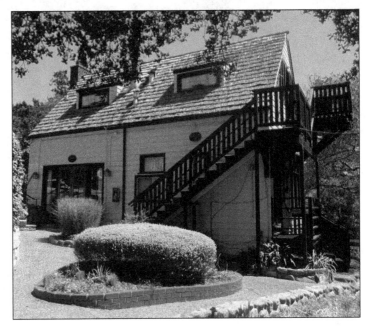

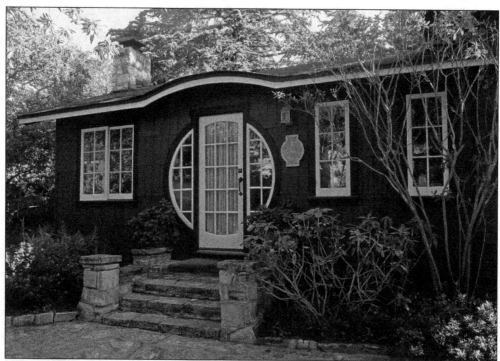

MRITZ DE HAASS HOUSE. Percy Parkes designed and constructed the eclectic wood-shingled Craftsman-style bungalow with a unique, circular entry on the northeast corner of Mountain View Avenue and Torres Street. It was built in 1925 for a Santa Monica businessman.

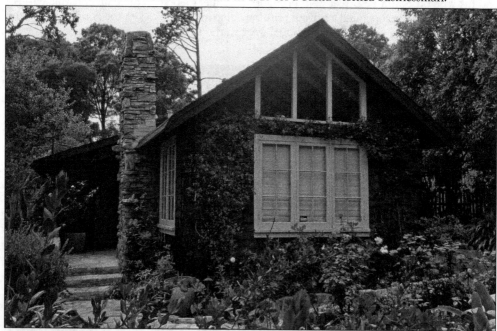

ELIZABETH H. SULLIVAN HOUSE. The Craftsman-style residence, located on the northwest corner of Santa Fe Street and Eighth Avenue, was designed and built in 1927 by Percy Parkes. He began work as a building contractor in 1911 in Los Angeles after quitting law school.

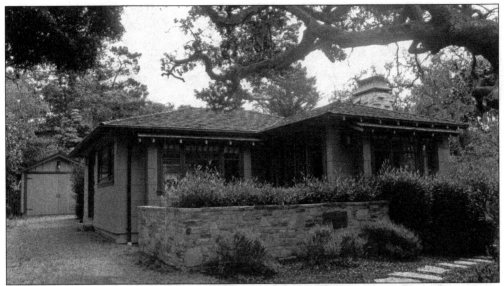

JACOB F. KREPS HOUSE. Percy Parkes designed and constructed the Craftsman-style bungalow on Torres Street 2NE of Eighth Avenue in 1926. Parkes came to Carmel in 1919. Through the 1920s, he did much residential and commercial work in various architectural styles.

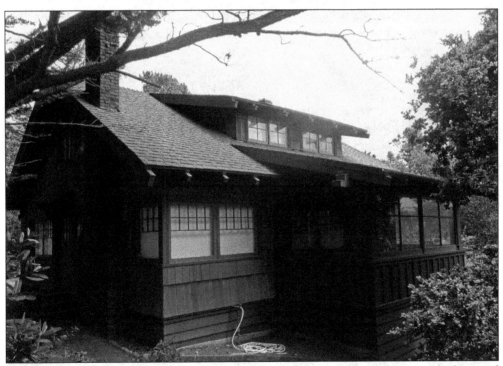

REV. CHARLES GARDNER HOUSE. The large, wood-shingled Craftsman-style house was built around 1904 by M.J. Murphy as a summer vacation home for Stanford University's nondenominational minister Charles Gardner and his family. It is on the northeast corner of San Carlos Street and Santa Lucia Avenue.

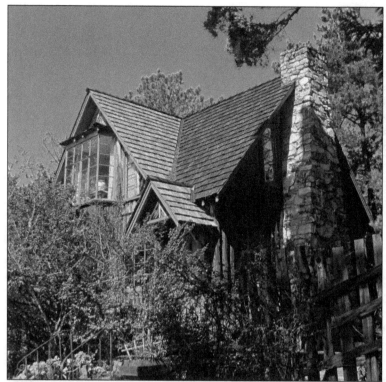

WILKINSON HOUSE. Real estate developer and contractor Carl Bensberg arrived in Carmel in the 1930s and worked through the early 1950s. He constructed the Tudor-style house at 26018 Ridgewood Road in 1940. He was known for his rustic designs with the use of half-round logs coated in clear varnish as exterior wall siding. The house had a large Carmel stone chimney and industrial steel casement windows.

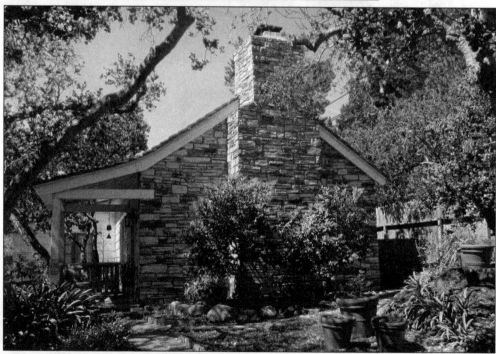

FLORENCE LOCKWOOD STUDIO/HOUSE. In 1940, Hugh Comstock built this Second Bay Region–style residence for Santa Cruz artist Florence Lockwood. Located on the southwest corner of Ocean Avenue and Forest Road, it featured an exterior wall and chimney covered with Carmel stone.

Five

NORTHEAST
HISTORIC HILL DISTRICT

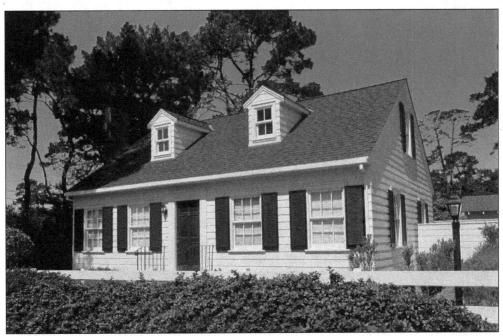

WAITE HOUSE. The Cape Cod–style house was constructed in 1951 on the northeast corner of Carpenter Street and Fifth Avenue by Pioneer Builders of Santa Cruz. It was built for Kathryn Waite, who was a secretary at the Pine Inn.

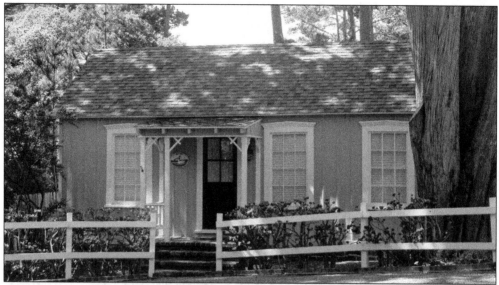

SANTIAGO DUCKWORTH HOUSE. Carpenter Delos Goldsmith built this one-story vernacular house in 1888 for the real estate agent who founded Carmel City that same year. Located on Carpenter Street 3SW of Second Avenue, it was one of the first homes constructed in the new community. Goldsmith was the town's first builder.

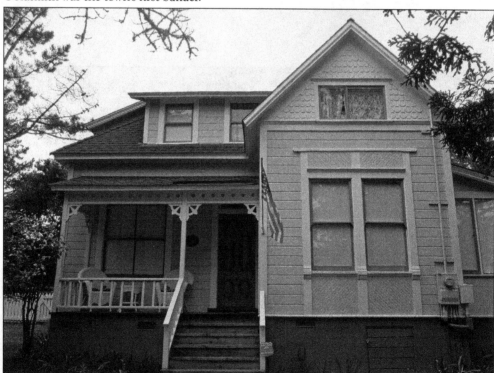

ABBIE JANE HUNTER HOUSE. The Queen Anne–style house on the northeast corner of Guadalupe Street and Fourth Avenue was built around 1894 by her relative Delos Goldsmith. Hunter ran the Women's Real Estate Investment Company in Carmel City until the economic downturn of the mid-1890s ended the real estate boom.

ALFONSO RAMIREZ CABIN. In 1888, Alfonso Ramirez, a Native American descendant, constructed this vernacular board-and-batten cabin on Santa Rita Street 3NE of Second Avenue. He operated the stage line that stopped nearby and had a corral for horses behind the residence.

BEN FIGUEROA HOUSE. The original house on Santa Rita Street 3SE of First Avenue was built in 1922. A Carmel contractor and stonemason of Portuguese heritage, Ben Figueroa made an addition in 1928 and became the owner. In 1937, Figueroa constructed the Carmel stone chimney, and M.J. Murphy did additional work on the house.

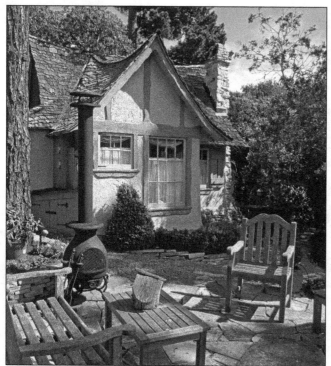

HANSEL. The first of 11 distinctive Tudor Storybook–style cottages Hugh Comstock built in the 1920s, in what became the Historic Hill District, is on Torres Street 4NE of Sixth Avenue. To create a textured look for the exterior finish, Comstock mixed pine needles into cement plaster, which was applied over burlap nailed to the walls.

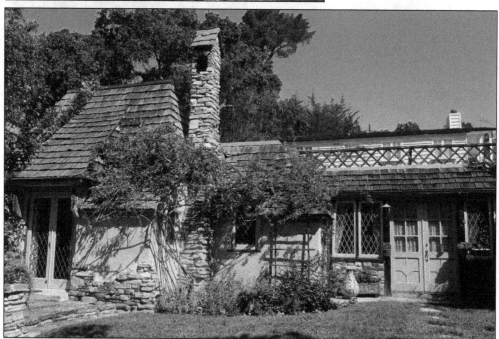

COMSTOCK STUDIO. Hugh Comstock constructed his studio and office in his signature Tudor Storybook style in 1927 at the northwest corner of Santa Fe Street and Sixth Avenue, next door to his home. For the roof, Comstock had used wood shingles dipped in a cement slurry mixture so they resembled slate and were more resistant to fire. Comstock's widow moved into the studio in 1953, three years after his death. His firm, Comstock Associates, continued until 1967.

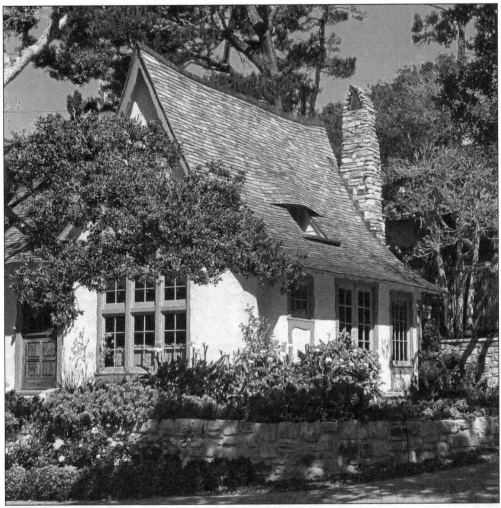

COMSTOCK RESIDENCE. In 1925, Hugh Comstock built his family home on the northeast corner of Torres Street and Sixth Avenue. Among its Tudor Storybook–style characteristics—which he frequently used—were a tall, narrow chimney covered in battered Carmel stone, a steeply pitched roof with overlapping wood shingles (that resembled thatching), flared roof eaves, and hand-carved wood window and door casings, all to create a rustic appearance. It was said that these handmade details seemed to give his fairy tale houses the look of having been created by gnomes. Other design features included false half-timbering, a Dutch door at the entry, wood French doors, rounded arch door hoods, and eyebrow windows in the roof plane. The original home was 400 square feet. In 1940, Comstock constructed a two-story addition with his new building material, Post-Adobe brick.

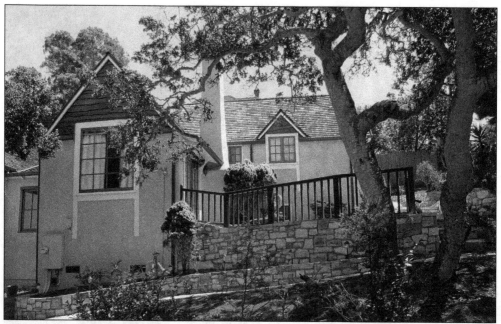

MARY YOUNG-HUNTER HOUSE. The Tudor Storybook–style house on the northeast corner of Torres Street and Ocean Avenue was designed and built by Hugh Comstock in 1927 for portrait artist Mary Young-Hunter. She came to Carmel with her daughter Gabrielle, who married Edward Kuster. It was his fourth marriage, and their son Colin was born in 1931.

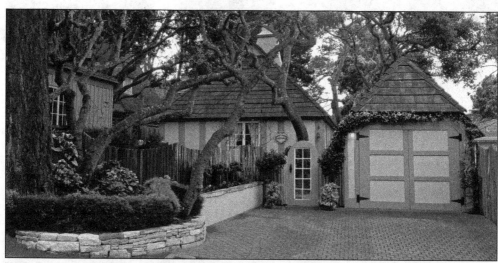

W.O. SWAIN COTTAGE NO. 1 (YELLOW BIRD). In 1928, Hugh Comstock designed and constructed five cottages for real estate investor W.O. Swain, who wanted to re-create an English garden–like subdivision. Each was furnished, equipped, and sold for around $5,000. The first was a 660-square-foot Tudor English–style cottage 2W of Santa Rita Street on the south side of Sixth Avenue.

W.O. Swain Cottage No. 2 (Doll's House). The second cottage was one of Comstock's larger Tudor Storybook–style houses. It is located on the northwest corner of Santa Rita Street and Ocean Avenue.

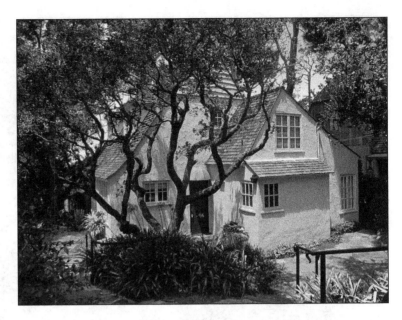

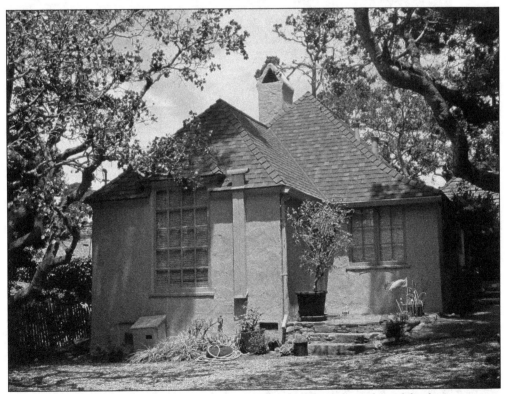

W.O. Swain Cottage No. 3 (Ocean House). The smallest and simplest of the five cottages is 2W of Santa Rita Street on the north side of Ocean Avenue. This third house was constructed in a vernacular, Tudor English Cottage style.

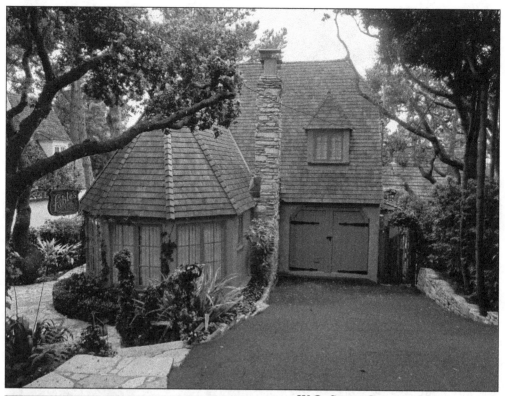

W.O. Swain Cottage No. 4 (Fables). The fourth house was built in a style that resembled a Norman French farmhouse. It is located on Santa Rita Street 2SW of Sixth Avenue.

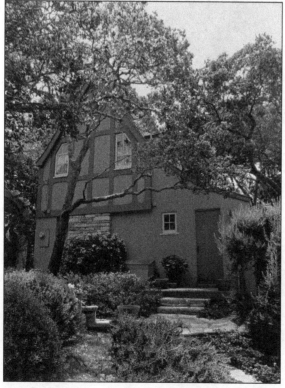

W.O. Swain Cottage No. 5 (Birthday House). The last of the five cottages Comstock built in the development was in the Tudor Storybook style, with Medieval English features. It is on the southwest corner of Santa Rita Street and Sixth Avenue.

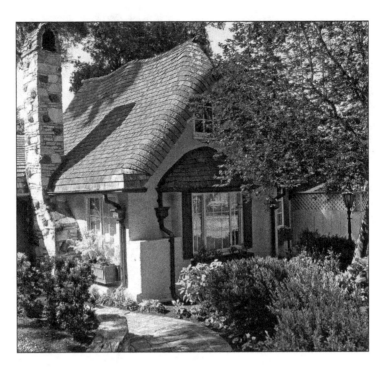

GRANT WALLACE COTTAGE. The Tudor Storybook–style cottage on the southeast corner of Torres Street and Sixth Avenue was constructed across from Hugh Comstock's residence in 1927 by builder Jess Nichols, who was Carmel's first city clerk. Grant Wallace, a San Francisco newspaperman, artist, and horticulturalist, designed the cottage. He was an eccentric man and was interested in metaphysics. His daughter Moira became an artist.

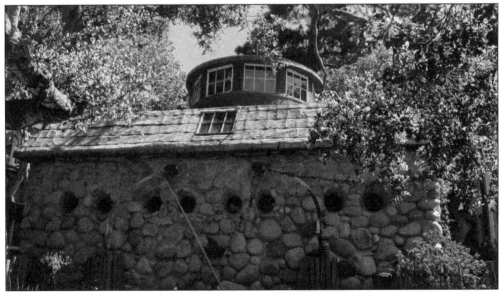

STONE SHIP HOUSE. Lifetime nautical collector Allen Knight loved the sea. He built this eclectic structure on Guadalupe Street 3NE of Sixth Avenue in 1939 for his growing collection of ship artifacts. It was made of old shipwreck pieces, with ship portholes in the granite stone walls, a copper roof, and a ship's wheelhouse. The Monterey History & Maritime Museum was established for Knight's collections after his death.

Visit us at
arcadiapublishing.com